C.F.A. VOYSEY

C.F.A. VOYSEY

ARCHITECT
DESIGNER
INDIVIDUALIST

Anne Stewart O'Donnell

Pomegranate

SAN FRANCISCO

DEDICATION 🐭 to my father

The author is grateful to

Bryan L. W. Draper

Collections Conservator

University of Maryland Libraries

for his kind assistance.

Pomegranate Communications, Inc.
Box 808022, Petaluma, CA 94975
800 227 1428 | www.pomegranate.com

Pomegranate Europe Ltd.
Unit 1, Heathcote Business Centre, Hurlbutt Road
Warwick, Warwickshire CV34 6TD, UK
[+44] 0 1926 430111 | sales@pomeurope.co.uk

Text © 2011 Anne Stewart O'Donnell

RIBA 🎗 Trust Unless otherwise noted: images © Royal Institute of British Architects (RIBA)
Library Drawings & Archives Collections; photographs © RIBA Library Photographs Collection

FRONT COVER: Design for a clock case for Voysey's own use, to be made in wood and painted in color (detail, fig. 40), 1895.

BACK COVER: Design for a poster for the Central Liquor Control Board called "Use and Beauty" (fig. 81), c. 1915–1918.

Library of Congress Cataloging-in-Publication Data

O'Donnell, Anne Stewart.
 C.F.A. Voysey : Architect, Designer, Individualist / Anne Stewart O'Donnell.
 pages cm
 Includes bibliographical references.
 ISBN 978-0-7649-5884-7 (hardcover)
 1. Voysey, Charles F. A., 1857–1941–Criticism and interpretation. I. Voysey, Charles F. A., 1857–1941. II. Title.

 N6797.V64O36 2011
 720.92—dc22

 2010044560

Pomegranate Catalog No. A193

Designed by Harrah Lord | www.yellowhousestudio.info

Printed in China
20 19 18 17 16 15 14 13 12 11 10 9 8 7 6 5 4 3 2 1

Contents

7 Introduction

13 Becoming an Architect

23 Pattern Design

45 The Heart of the Matter: Individuality

55 At Home with Mr. Voysey: Interiors, Furniture, Metalwork

73 Humor and Grotesques

85 Rise and Fall

106 Endnotes

108 Bibliography

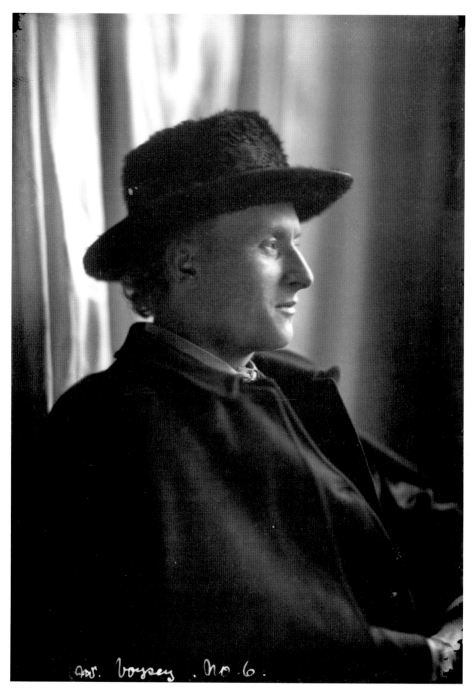

1. C. F. A. Voysey in 1884

INTRODUCTION

"At once simple and noble." "Fresh and serene." "Lovable." "Like Spring re-born." Europe's most eminent critics and architects described Charles Francis Annesley Voysey's work in terms like these.[1] "He created that with which you could laugh," declared the architect Edwin Lutyens, "a renewed vision . . . an old world made new . . . the promise of a more exhilarating sphere of invention."[2] "In the same sense that Kipling invented the short story, Voysey may be said to have invented the small house," stated *The Architect & Building News* in a 1927 tribute. "Voysey was not only prolific in ideas, but set architects in a new relation to their work. It is not only the things he did, but more particularly the spirit in which he addressed himself to his tasks, which places architects and architecture in his debt."[3]

For a decade on either side of 1900, the ingenuity, the simplicity, and the humanity of Voysey's designs charmed and challenged artistic minds, whether British, European, or American. Advocates of Art Nouveau and exponents of Modernism claimed him as an inspiration (though in each case he objected, having little sympathy with either movement—or indeed, as what he called an "Individualist," with movements in general). Voysey created some of the period's most accomplished wallpaper and textile designs—but urged the public to avoid using patterns in interiors. Following his own ground rule, "We cannot be too simple,"[4] he banished dust-catching moldings from his houses, and even cuffs and lapels from his trousers and jackets. Yet to Voysey, simple never meant joyless or bland. The Orchard, his much-publicized home, glowed with purple walls, Turkey-red curtains, green tiles, and a peacock rug, and the blue shirt beneath his streamlined jacket was likely to be "the brightest thing in the room."[5]

Firsthand accounts of Voysey's personal side are few; those that do exist hint at interesting contradictions. "He was the sort of man you would never dream of taking any liberty with. You would probably have hesitated to introduce yourself," his nephew-in-law recalled. "Automatically he commanded your respect." But for all that, "the most remarkable thing about him, I think, was his smile. It was a lovely smile. There was more kindness and more simple delight in humour and more sheer affection in that smile than in any smile I have ever beheld."[6]

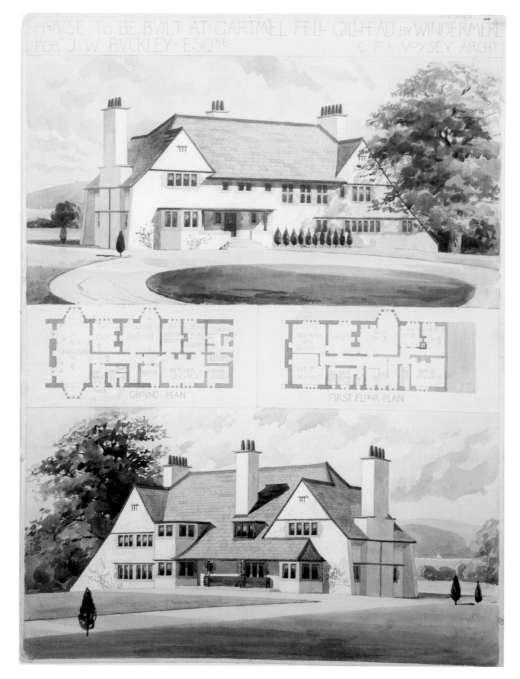

2. **Design for Moorcrag at Gillhead, near Windermere, Lancashire, 1898**
Watercolor, 535 x 410 mm

Moorcrag, on Lake Windermere in the Lake District, embodies Voysey's architecture at its best: a modest yet comfortable country home, very modern at the time in its simplicity and its renunciation of historic trappings. The massive chimneys, ribbons of casement windows set in stone surrounds, and buttressed roughcast walls are favorite Voysey elements.

3. **The Homestead, Frinton-on-Sea, Essex, 1906**
Photograph by Morley von Sternberg

Voysey's houses evoke no specific historic style, but their textured roughcast surfaces, stone window surrounds, and slate or tile roofs lend them a comfortable, traditional feeling.

4. **Design for a machine-woven textile called "Huntsman," c. 1919**
Colored washes, 585 x 400 mm

The Essex & Co. wallpaper firm billed Voysey as "the Genius of Pattern," and with good cause. His design career covered nearly half a century, and in his heyday, his wall coverings and fabrics were internationally popular. His "Huntsman" pattern teems with plants, animals, and whimsical detail.

5. **Design for a wallpaper called "The Callum," c. 1896**
Pencil and yellow and green washes, 500 x 310 mm

"The Callum," also known as "Mimosa," exemplifies Voysey's seemingly effortless orchestration of color and simple form.

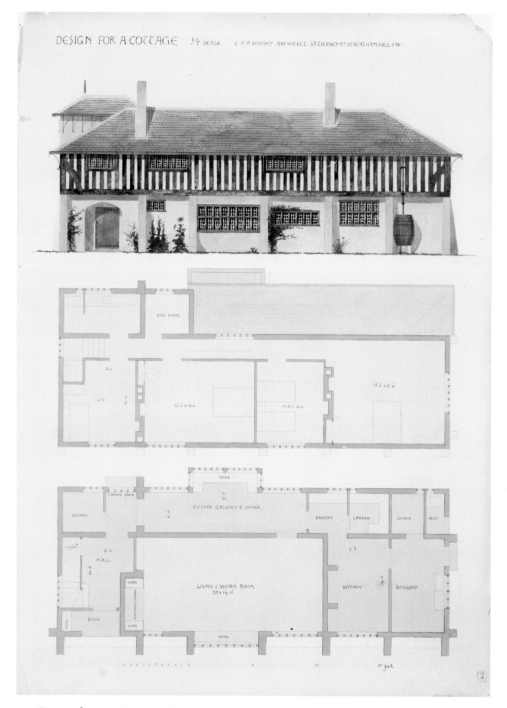

6. Design for a cottage, c. 1885
Watercolor, 660 x 475 mm

Voysey's first executed architectural project was a house for Michael Lakin adapted from this "cottage" design, published in *The British Architect* in 1888.

❦ Becoming an Architect

In 1896 *The Studio*, a magazine of international influence in the fields of art, architecture, and design, noted a new milestone in Voysey's rise to design prominence: When it came to wallpaper, *Voysey* had become an adjective.[7]

The name was already famous, however—some might say notorious. Voysey's father, the Anglican minister Charles Voysey, was expelled from the church in 1869 after a celebrated trial for heresy (fig. 7). An outspoken man of faith with a strong reformist bent, the Reverend Voysey had argued against the divinity of Christ, the existence of Hell, the need for clergy as intermediaries between God and His people, and the literal truth of the Bible. He wasn't the first to raise such doubts, but Anglicanism was already reeling from the 1859 publication of Charles Darwin's *On the Origin of Species*, and the Voysey controversy was eagerly followed by the public. The Reverend Voysey won the support of Darwin himself, of thinkers such as John Ruskin, and even of some senior church officials; nevertheless, his appeal was denied and his expulsion upheld. He soon founded a new faith, Theism—"the Religion of Common Sense"—which embraced the scientific and philosophical explorations that characterized the Victorian age.[8]

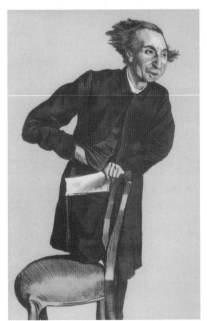

Born in 1857, C. F. A. Voysey spent his early years primarily in London and Yorkshire. The drama surrounding the trial dominated his childhood, and the Reverend Voysey's convictions, and his refusal to abandon them, left a lasting impression on the boy. "[Voysey's] sense of the matter is that he owes everything to his father," reported an interviewer nearly sixty years later. "That all his beliefs . . . are part and parcel of the fabric of his father's thought and teaching. This early entrenchment

7. *Vanity Fair* caricatured the Reverend Charles Voysey, C. F. A.'s father, in 1871, after his expulsion from the Anglican Church.

Photograph courtesy of author

with a complete system of ideals and precepts explains much of the obstinate firmness and tenacity of Voysey to the principles he stands for."[9] Voysey decided early in his career that humankind's spiritual growth hinged on qualities such as love, reverence, humility, self-sacrifice, simplicity, and truthfulness—and that these were far from abstract; they could and must be given concrete form, in the humblest articles of daily life as well as in homes and public buildings. Every house Voysey built, every pattern he drafted, every chair or coat hook he designed, reflected this conviction. John Betjeman spoke to this material embodiment of spirit when he wrote, "What his father preached to thousands in London, Mr Voysey has interpreted in stone and colour."[10]

The Reverend Voysey's influence on his son was all the stronger because he educated the boy himself, at home, until C. F. A.'s early teens, when he was sent to Dulwich College in London for eighteen months. The Dulwich period was not young Voysey's finest hour; he performed poorly, and the drawing master, a distinguished Member of the Royal Academy, pronounced him "quite unfit for an artistic profession" (a statement Voysey recalled with delight in later life).[11] It is hard to know whether he chose architecture as a career in spite of this verdict or because of it. The fact that his grandfather Annesley Voysey had been an "engineer-architect," a builder of bridges, lighthouses, and churches, undoubtedly played a role in the decision.[12] C. F. A. would later claim that "I determined to become an architect because it was the only profession I could take up without passing any examinations."[13]

In the most comprehensive study of Voysey's career to date, Wendy

8. Design for a wallpaper called "The Heylaugh," c. 1895
Green, purple, and yellow washes, 775 x 560 mm

Design historian Stuart Durant has identified "Heylaugh" as an alternate spelling of Healaugh, the Yorkshire parish held by Reverend Voysey at the time of his heresy trial.* The design's easy curves and gentle coloring belie the drama that must often have characterized life for the Voyseys at that period.

*Durant, *Decorative Designs*, 47.

Hitchmough has traced the influence exerted on him by four key figures: the critic John Ruskin, the Gothic Revival architect A. W. N. Pugin, and the two architects in whose offices Voysey chiefly trained, John Pollard Seddon and George Devey. She surmises that since Ruskin was a supporter of the Reverend Voysey, it was probably through his father that C. F. A. began to learn of Ruskin's theories on morality, art, nature, the unholiness and repression inherent in the Classical tradition, and the creativity, vitality, and freedom represented by the Gothic—ideas that would become integrally woven into Voysey's personal and architectural worldview.[14]

Hitchmough also notes that the Reverend Voysey had watched as a child when Pugin showed Annesley Voysey his plans for the Gothic Revival interiors of the Houses of Parliament, for which Pugin designed everything from floor tiles to door hardware.[15] This piece of family history, she suggests, may have underlain C. F. A.'s lifelong admiration for Pugin, whom he praised as one who had mastered the principles of Gothic so completely that he could fulfill any modern need in flawless Gothic style without committing the sin of direct imitation.[16] ("You may search the Houses of Parliament from top to bottom," Voysey wrote approvingly, "and you will not find one superficial yard that is copied from any pre-existing building."[17]) Hitchmough points out that Pugin was also the author of "the two great rules for design" to which Voysey faithfully adhered: "1st, that there should be no features about a building which are not necessary for convenience, construction or propriety; 2nd, that all ornament should consist of the essential construction of the building."[18]

One of Pugin's architectural heirs was John Pollard Seddon, whose practice Voysey joined as a pupil in 1874, around his seventeenth birthday.[19] A specialist in building and restoring churches, Seddon aimed to develop a "Modern Gothic" for new types of secular buildings, interpreting Gothic principles, as did Pugin, rather than copying actual details. Also like Pugin, he was not merely an architect but a decorative designer as well, creating stained glass, ecclesiastical embroideries, and furniture. Hitchmough observes that Seddon had worked with William Morris and members of his circle, including Dante Gabriel Rossetti and Edward Burne-Jones, and he also counted the architects E. W. Godwin and William Burges among his good friends. These men often visited Seddon's home and office, and young Voysey must have learned much from their discussions of design and from the example they offered as "passionate and extravagant

individuals who set their own rules for life as well as for art."[20]

After five years as Seddon's student, Voysey worked for a further year as his assistant. Then, after a brief stint in the office of Henry Saxon Snell, designer of hospitals and other institutions, he moved to the office of George Devey, a country house architect to Rothschilds and royalty. Hitchmough contends that Voysey's experiences under Devey stood him in good stead in his later career—though probably not in ways he would have anticipated.[21] Devey, who had studied traditional regional and rustic building styles since the 1840s, used this knowledge of the vernacular to surround his clients' elaborate, eclectic mansions with cottages and stables that looked as if they had been in place for centuries. Entrusted with designing and overseeing construction of many of these ancillary buildings, Voysey would have absorbed much about the planning of smaller, purely functional structures and about how rural builders, unconcerned with fashion, had used the materials around them to address the needs of their particular time and place; he must often have recalled these examples a few years later, as he found himself virtually reinventing the modest middle-class English country home.

Nevertheless, when Voysey launched his own practice in 1881, he seems to have had Devey's grander projects on his mind rather than these simple outbuildings. Although in later life he came to criticize Devey's manor-house style as "bastard Jacobean,"[22] his first solo designs bristled with favorite Devey details: quaintly patterned brickwork, half-timbering, Dutch gables, and tall chimneys.

It's intriguing to speculate where Voysey's career would have taken him if any of his earliest proposals had actually been built—the Deveyesque "house with an octagonal hall," the half-timbered sanitarium for a company in Devon, or his ambitious

9. Voysey and his wife, Mary Maria Evans Voysey, 1903

competition entry for the Admiralty Offices in Whitehall. But architectural commissions were slow in coming; it was the discovery of a talent for designing wallpapers and fabrics that kept his head above water early on. He married Mary Maria Evans in 1885, and designed a home for them to share—a half-timbered "cottage" with many of the elements that would become his standards: a roughcast exterior, buttresses, an extended upper floor, and bands of windows nestled below the roofline (fig. 6). He couldn't afford to build the house himself, but the drawings were published in an architectural journal in 1888, where they caught the eye of one Michael Lakin. A cement manufacturer, Lakin asked Voysey to adapt the design to produce a small house near his factory, probably to show the potential of concrete in building; Voysey obliged (no doubt working closely with Lakin), scrapping the half-timbering and specifying innovative concrete tiles for the roof.[23]

The year 1888 also saw the first version of a design for a house in Bedford Park, Chiswick, London's fashionable new garden suburb with homes in the ornately cozy Queen Anne style made popular by the architect Richard Norman Shaw. When 14 South Parade was completed in 1891, the commuters who rolled past it on the District Line train must have been startled by the austere white roughcast façade, upright and prim among the neighboring brick gables with their terra-cotta swags and red-clay tilework (figs. 10–12).[24]

The architectural press was bemused by the home's unusual simplicity—"It was found necessary, in order to prevent the builder from displaying the usual 'ovolo mouldings,' 'stop chamfers,' fillets and the like, to prepare eighteen sheets of contract drawings to show where his beloved

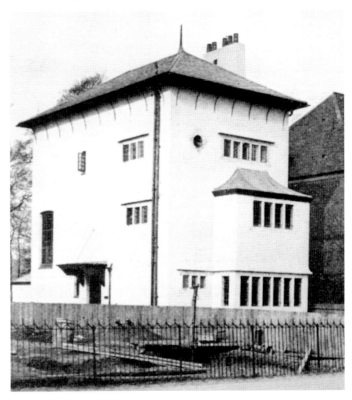

10. Period photograph of 14 South Parade, published in *Architectural Review*, October 1927

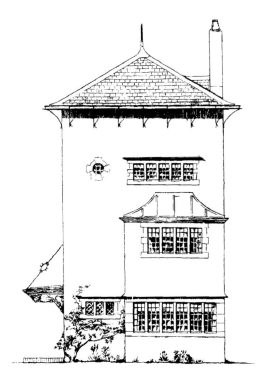

11. Elevation of 14 South Parade, Bedford Park, London, published in *The British Architect*, 1891

ornamentation *was to be omitted*"—and by the resulting low cost: "£494 10s., a price that takes one's breath away."[25] But Voysey had found his direction, one rooted in the conviction that architects must abandon any attempt at a preconceived style and design each home afresh, based on the client's fundamental needs and on the constraints and opportunities of climate, location, and materials. To 1890s eyes, the results seemed daringly stripped down, yet surprisingly liveable. By 1897 *The Studio* could report that "Mr. Voysey is not a mere dreamer, but a practical and experienced architect, who will give you first a sanitary, substantial, and comfortable house, and in doing so—with no extra cost, but often with a most unusual economy—manage to make it a really artistic building at the same time."[26]

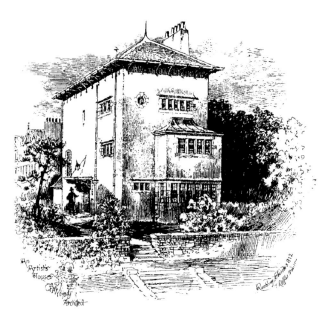

12. Perspective sketch of 14 South Parade, published in *The British Architect*, 1891

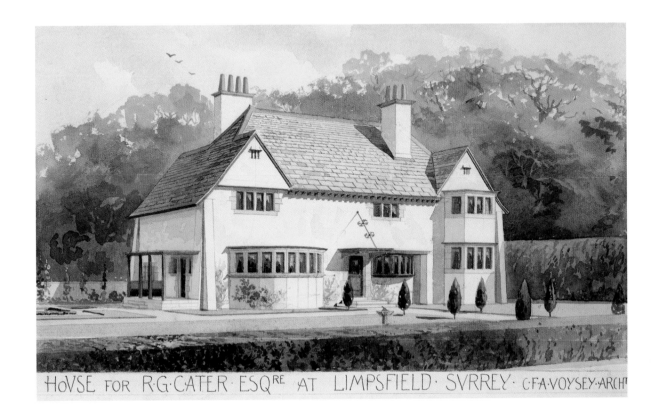

HoVSE FOR R·G·CATER·ESQ^{RE} AT LIMPSFIELD·SVRREY· C·F·A·VOYSEY·ARCH^T

13. **Design for a house in Limpsfield, Surrey, 1897**
Watercolor, 300 x 455 mm

"Clients who came to him wanted inexpensive houses," *The Architect & Building News* reported in 1927, "and a 9-inch brick wall, roughcast, was the cheapest weathertight wall that could be built, and buttresses were introduced to restore to the wall the stiffness which it lacked." They also offered endless opportunities to create sheltering nooks or add visual interest.

14. Design for Dixcot, North Drive, Tooting Bec Common, Streatham, London,
for R. W. Essex, 1897–1898
Watercolor, 785 x 515 mm

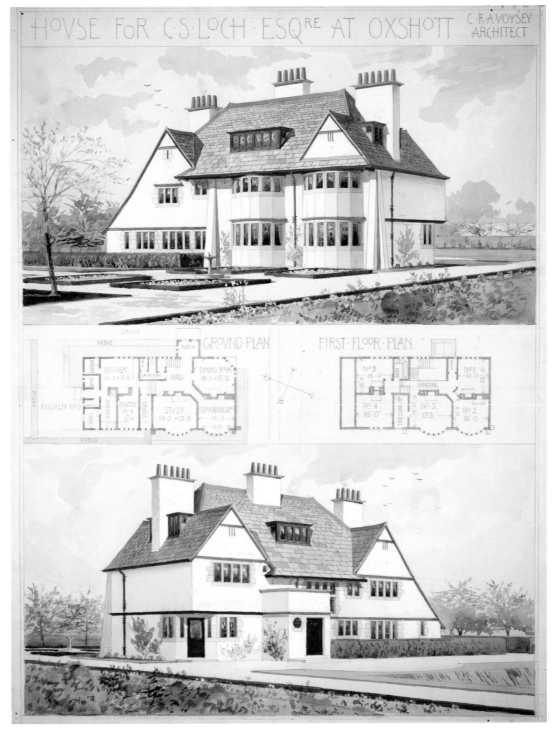

15. Design for a house in Oxshott, near Esher, Surrey, c. 1898
Watercolor, 495 x 385 mm

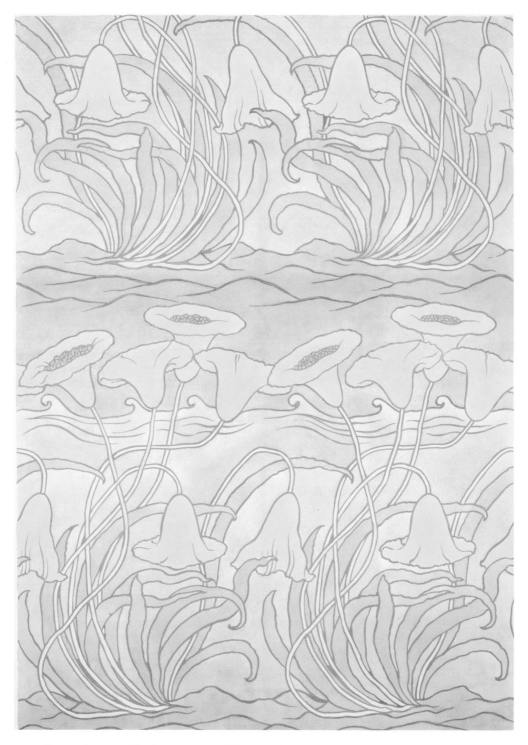

16. Design for a textile showing water lilies growing in a stream, 1888
Yellow, green, blue, and gray washes, 780 x 560 mm

PATTERN DESIGN

THE IDEA THAT THE "FINE ARTS" were separate from, and superior to, the "lesser" or decorative arts increasingly came under attack as the nineteenth century proceeded. By the time Voysey opened his practice, the belief that "all that was necessary for daily life could, and ought to be, made beautiful"[27] was common among the progressive architects and designers in whose company he had begun to move. Later he would applaud Godwin, Burges, G. F. Bodley, and A. H. Mackmurdo as leaders in acting on the principle that "nothing in or outside a home [was] too small to deserve their careful consideration."[28] It was Mackmurdo who drew Voysey into the field of decorative design.

A former pupil of Ruskin and a trained architect, Arthur Heygate Mackmurdo made a systematic study of Gothic cathedrals and the Renaissance riches of Florence before returning to England with the idea of forming a group of artist-designers similar to William Morris's firm, a group that would "restore building, decorating, glass-painting, pottery, wood-carving, and metal-work to their rightful place besides painting and sculpture . . . and by thus dignifying Art in all its forms . . . make it living, a thing of our own century, and of the people."[29] He founded the Century Guild in 1882, just as Voysey was settling into his practice and finding clients slow to materialize. One day, according to story, Voysey dropped in on his friend, found him busy devising wallpaper patterns for Jeffrey & Co., and casually decided to try his hand.[30] Mackmurdo provided guidance in technical matters, such as how to create designs for machine-woven carpets on point paper (graph paper); but Voysey needed no coaching when it came to orchestrating line, shape, and color into intricate, pleasing rhythms, and he realized he had discovered a talent that could provide a steady income while he built up his architectural practice.[31] He sold his first papers in 1883, to Jeffrey & Co.; eventually he won long-running contracts with several makers of wall coverings, woven and printed fabrics, and machine-made and hand-tufted carpets, guaranteeing him annual fees in return for submitting a set number of designs each year.

Voysey proved to be "peculiarly fecund in the invention of patterns," as *The Studio* put it.[32] As diverse as his designs can be, however, they exhibit a basic

kinship both among themselves and among patterns by other reform-minded British designers—including Mackmurdo, other Century Guild artists, and Morris himself—in that their motifs, almost always plant forms, were stylized (or, in the term of the day, "conventionalized") to a greater or lesser extent. In reformist circles, realistic representations that gave the illusion of three-dimensionality were viewed as "dishonest"—cabbage roses were *not* actually growing up the parlor wall, so why try to fool the eye that they were? Further, to make an exact copy of a particular flower or leaf was considered an almost mechanical exercise, much like taking a photograph, whereas "conventionalizing" demanded an investment of human intellect and spirit that many believed could communicate itself beneficially to those who lived with the resulting design. Voysey not only subscribed to this widely held view, he made it part of his religious doctrine.

Voysey's devotion to honesty in pattern design extended beyond conventionalization to a determination not to hide the nature and limitations of the medium. When asked in 1893 what constituted a good design, Voysey replied that "a wall-paper should be always essentially a pattern, the repeat

of which is recognised as one of its chief characteristics, rather than a pattern disguising the repeats."[33] Thus, tempting as it is to dwell on the small details of Voysey's design drawings, it should be remembered that the primary intended effect, usually a net structure or horizontal stripe, does not reveal itself unless multiple repeats are taken into account.[34]

Voysey was certainly not the first designer to emphasize pattern; his great contribution lay in his transformation of flowers, trees, and other natural forms into flat shapes or silhouettes—often with no linear detail at all—then building complex and exciting patterns from these elements (figs. 18–20).[35]

17. **Design for a wallpaper, for Essex & Co., c. 1896**
Colored washes, 440 x 420 mm

18. **Design for a wallpaper showing stylized birds and poppies, c. 1890**
Pink washes, 555 x 375 mm

As charming as Voysey's details can be, the larger structure they created was always paramount; to understand the intended effect, his designs should be envisioned in multiples. Seen at a distance, the birds and poppies in this drawing would create a basketweave look.

19. Design for a wallpaper, for Sanderson & Sons, c. 1907
Pencil and green, yellow, and black washes, 765 x 560 mm

20. Design for a wallpaper frieze called "Shallop," redrawn in 1900 after an 1893 original
Green monochrome wash and colored washes, 780 x 560 mm

Voysey further pushed the boundaries in his selection of motifs. "Toadstools and fungi . . . have, one suspects, never inspired decorators before Mr. Voysey was attracted by their quaint forms,"[36] observed one critic approvingly. The "Claudea" design (fig. 21) depicted *Claudea elegans*, a red seaweed native to the waters around Australia; the 1886 "Pentacrinus" paper represented a fossilized marine creature with a plant-like stalk and petal-like waving tendrils.[37] But Voysey faced an uphill battle when he attempted to introduce birds and countryside animals into his designs. Mystified and irritated by what he called "the unreasonable, unhealthy, and insane opposition to the conventional application of *animal* life to decoration,"[38] he made his case in more than one article and lecture:

> I do not see why the forms of birds, for instance, may not be used, provided they are reduced to mere symbols. Decorators complain . . . because the figures may be mutilated, in turning a corner for instance. If the form be sufficiently conventionalised the mutilation is not felt; a real bird with his head cut off is an unpleasant sight . . . but if the bird is a crude symbol . . . it does not violate my feelings.[39]

Voysey later expressed gratitude to the wallpaper manufacturer Walter Essex for publishing and promoting these papers when "all his friends told him he was a fool to do so."[40] As a result, Voysey was able to produce some of the most

**21. Design for a wallpaper or textile called "Claudea,"
dated April 1890**
 Green, blue, and red washes, 510 x 450 mm

Here, the red coloring, juxtaposed with blue waves, reflects the natural hue of *Claudea elegans*, a seaweed found near Australia.

22. **Design for a wallpaper showing birds among grapes and leaves, 1906**
Pencil and colored washes, 740 x 550 mm

23. Design, possibly for a nursery wallpaper, dated August 1930
Pencil and colored washes, 735 x 550 mm

beguiling wall coverings and textiles of the period. He had a gift for capturing the essence of a species with a simple outline, with a precisely placed dot for an eye and perhaps a stroke to indicate the edge of a leg or wing. More than that, he knew how to convey the idea of a living creature in motion, or on the verge of motion, by incorporating its weight, momentum, and characteristic way of moving into its silhouette (see the huntsman in fig. 4, the squirrel in fig. 23, and the birds in "Squire's Garden," fig. 61). Finally, no matter how simple, naïve, or even childlike his renderings are, Voysey's respect for the animal kingdom always comes through. Each of his creatures is absorbed in being itself; he rarely, if ever, personifies an animal or makes it "cute."

WHILE VOYSEY NEVER JOINED the Century Guild, he enjoyed the company and support of its artists, especially the energetic and innovative Mackmurdo. Mackmurdo's realization that good design could be propagated beyond the wealthy few only with the help of industry, and his willingness to explore how machines could best produce an artistic end product, had a strong influence on Voysey; "Mackmurdo's furniture," he wrote, "showed how the machine should be recognized by the designer, and led many in his day to revolt from over-decoration and strive for the straight, simple and plain."[41] Mackmurdo's booth at the Liverpool International Exhibition of 1886 featured tall, slim columns with square capitals and a railing with straight-edged spindles; Voysey would adapt both features for use in his furniture and staircase designs (figs. 44, 46, 47).

In 1884 Voysey joined the newly founded Art Workers Guild, a social group that brought artists, designers, and architects together twice a month to discuss design issues and promote the "Unity of the Arts." There he exchanged ideas with established designers such as Walter Crane and William Morris, as well as with emerging talents. The guild's offshoot, the Arts and Crafts Exhibition Society, was formed in 1887, giving its name to the movement that had been developing through the decade. Voysey shared many Arts and Crafts ideals—exaltation of the workman's joy in labor, faith in the moral power of good design, the idea of truth to materials—but he distrusted Morris's socialism and what he called his "atheism."[42] Voysey's relationship to Morris was a strange one: he conceded that Morris had eased the way for his own generation of designers, having "prepared the public mind and educated it," creating a market for artistic furniture, textiles, and the rest.[43] He also acknowledged the power of the older designer's creative

vision, remarking that he avoided the Morris & Co. shop "lest his own designs degenerate into copies of Morris."[44] However, he generally had little praise for Morris or simply left him out of his accounts of the era. The words of an interviewer in 1927 may reveal a touch of jealousy on Voysey's part:

> Morris had a great advantage over Voysey: he controlled the whole process of manufacture until the paper left the printing machine and the fabric the loom . . . Voysey had no such opportunities. His work ended with the making of the design, and he . . . had no control over the use made of his design, which, if a wallpaper, was not necessarily printed in the tints he had fixed . . . and [was produced] by machinery on any kind of paper which the manufacturer chose to use.[45]

Lack of control and unsatisfactory quality may have bedeviled Voysey's first years as a designer—in 1886, for instance, the seventeen papers he designed for Woollams could each be had in a choice of six colorways, some enhanced with lacquered gold, mica, or flocking.[46] Ten years later, however, he apparently had little cause to complain: *The Studio* hailed "the really wonderful printing of [the "Bird and Tulip"] design in a varied series of colour-schemes for which Mr. Voysey (in co-operation with Mr. Essex) is responsible . . . One variety especially, in rich purples and greens, is more lustrous and fine than any wallpaper which we can call to mind for comparison."[47] In fact, the writer had visited the Essex factory

> when the head of the firm and Mr. Voysey were busily engaged in approving or rejecting the trial proofs of various schemes of colour for the publications of the coming year. Those who think that a good designer has completed his work when he has invented a pleasant pattern . . . would be startled did they realize that this finished drawing is but the initial step . . . [I]n these papers Mr. Voysey has . . . mixed certain groups of colors for the printers to match, and in close cooperation with the maker himself [has engaged in] unsparing revision and readjustment of the design which makes the resulting product, not a mechanical facsimile of the watercolour, but . . . a product that is exactly suited for its intended purpose . . . infinitely more artistic than would be a literal facsimile.[48]

Voysey himself maintained that "to produce any satisfactory work of art, we must acquire a complete knowledge of our material, and be thorough masters of the craft to be employed in its production."[49] That he understood machine weaving as well as wallpaper printing is borne out by notes he made on his textile designs for Alexander Morton & Co., giving hints for obtaining desired results—as with "Halcyone" (fig. 56), where he wrote on one version, "It is hoped the broken effect of colour in the background can be got by mixing the color of the bird and sea together *horizontally*."[50]

On the Continent, as the nineteenth century closed, proponents of what would come to be called Art Nouveau were as eager as these British guilds to find new roles for design. Abandoning historic styles as irrelevant to modern life, adherents of the New Art looked to nature for inspiration and sought to bring the touch of the artist to every aspect of the home. Patterns by Crane and Morris and other English designers were popular in Europe, and as Voysey's work became known, he, too, joined the list of favorites.[51] The Belgian Art Nouveau architect Henry van de Velde praised Voysey in an 1893 article on "Artistic Wallpaper," and his compatriot Victor Horta used a Voysey paper in his Hôtel Tassel (Brussels, 1892–1893; now considered the first example of Art Nouveau architecture) and another in his Hôtel Solvay (Brussels, 1896).[52] But Voysey, like many other British designers, condemned the sinuous whiplash curves of continental Art Nouveau as extreme and associated the style with the fin-de-siècle decadence represented by the excesses of Oscar Wilde and Aubrey Beardsley.[53] Voysey called the movement's departure from historic styles "a distinctly healthy development," but believed that

> at the same time the manifestation of it is distinctly unhealthy and revolting . . . the work of a lot of imitators with nothing but mad eccentricity as a guide; good men, no doubt, misled into thinking that Art is a debauch of sensuous feeling, instead of the expression of human thought and feeling combined, and governed by reverence for something higher than human nature.[54]

It may have been partly in reaction to the lush curves of Art Nouveau that Voysey's patterns took on a greater lightness and simplicity between about 1905 and 1910 (fig. 24).[55]

24. Design for a wallpaper featuring stylized roses, rose hips, and leaves, 1906
Pencil and colored washes on tracing paper, 595 x 570 mm

Voysey's own opinion of pattern was that a little went a very long way, and he did not mind sharing this view with *The Studio*'s readers. "A wall-paper is of course only a background, and were your furniture good in form and colour a very simple or quite undecorated treatment of the walls would be preferable, but as most modern furniture is vulgar or bad in every way, elaborate papers of many colours help to disguise its ugliness."[56] He preferred good wooden paneling, if the homeowner could afford it; if not, painted deal paneling. Yet he continued to design wall coverings and fabrics, and in the home he built in 1899, The Orchard, he broke his own dictum, using his own papers in the bedrooms and even in his study. It may be that Voysey simply couldn't help "revel[ing] in the beauty of intricate line"[57] and indulging what he called his "playful delight in bird life and strong joyful colour."[58]

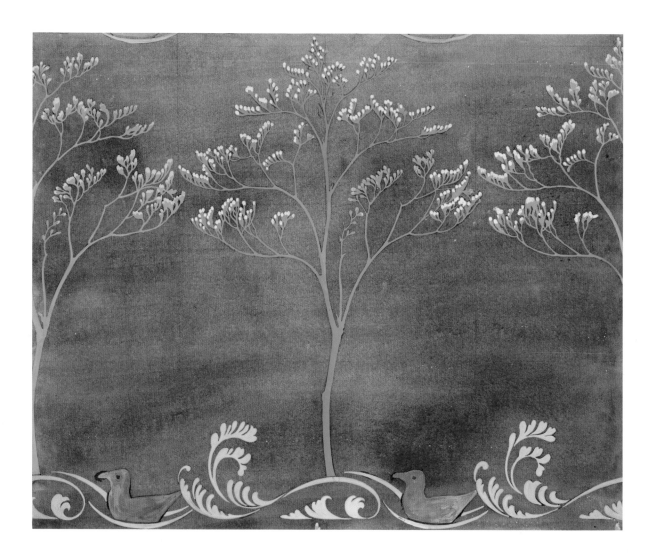

25. Design for a wallpaper frieze called "Seagull," c. 1893
Blue wash and green, gray, and white body color, 475 x 565 mm

26. Design, probably for a nursery textile, 1929
Pen and colored washes, 400 x 565 mm

Voysey revisited and "recycled" designs and motifs throughout his career. Drawn in 1929 for Alexander Morton, but rejected, this unusual design for a printed linen is very much in Voysey's twentieth-century style of loosely scattered motifs. Overall, it is quite different from a swirling seaweed design Voysey drafted in 1888, which is now in the Victoria and Albert Museum; however, despite a gap of over four decades, a nearly identical octopus appears in each.*

*Brandon-Jones and others, *C.F.A. Voysey*, 118-119.

27. Design for a wallpaper and textile, 1900
Pencil and colored washes, 390 x 340 mm

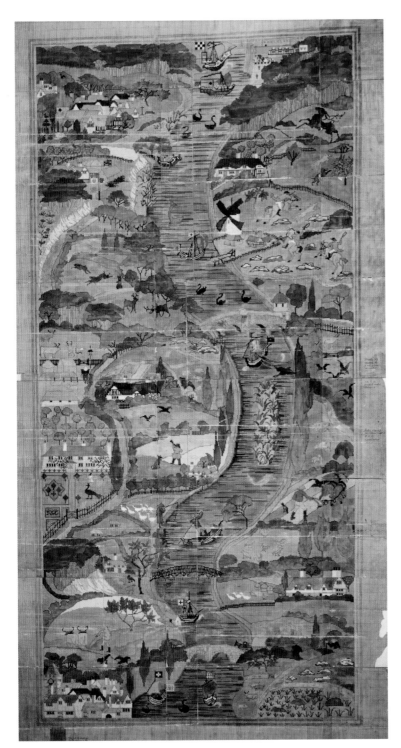

28. Design for the "River Rug," for Yates & Company, 1903

Colored washes on squared paper laid down on linen, 640 x 315 mm

For the "River Rug"—not a pattern at all, strictly speaking—Voysey captured the plants, animals, and human pursuits of rural England in a miniature landscape evocative of a medieval book of hours. With their buttressed sides, white walls and chimneys, and ribbons of windows, several of the houses are strongly Voyseyesque. The gray-roofed house at extreme left recalls a preliminary design for Perrycroft (1893),* while the peacock on its grounds, the black sundial on a white plinth, and the roses trained along the walls echo the "Squire's Garden" wallpaper (fig. 61). The eight-by-four-foot rug was produced by Yates & Co. and displayed at the Arts and Crafts exhibition in 1903.†

*Reference number SB121/VOY[32]3, RIBA Library Drawing & Archives Collections. Viewable online as number RIBA12750, RIBApix online image database, http://www.ribapix.com.
†Symonds, *C.F.A. Voysey*, 76.

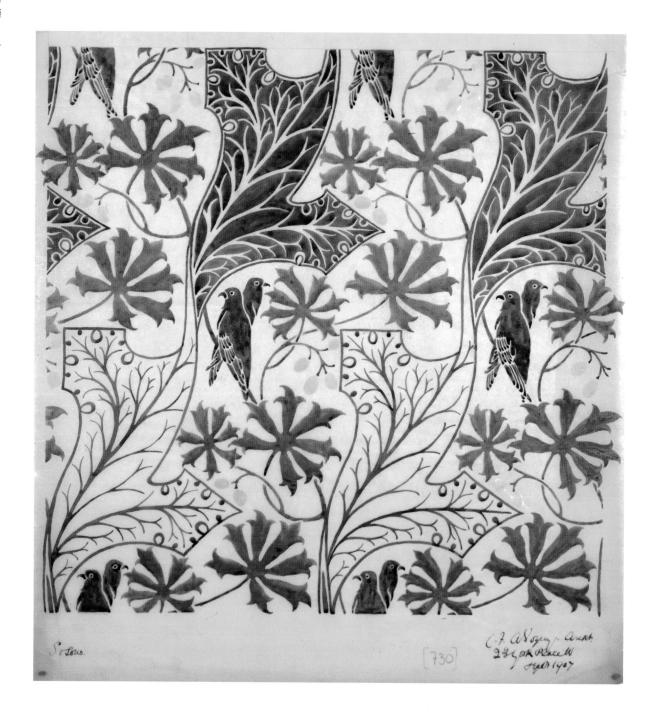

29. Design for a wallpaper, for Sanderson & Sons, 1907
Yellow, green, and purple washes on tracing paper, 755 x 570 mm

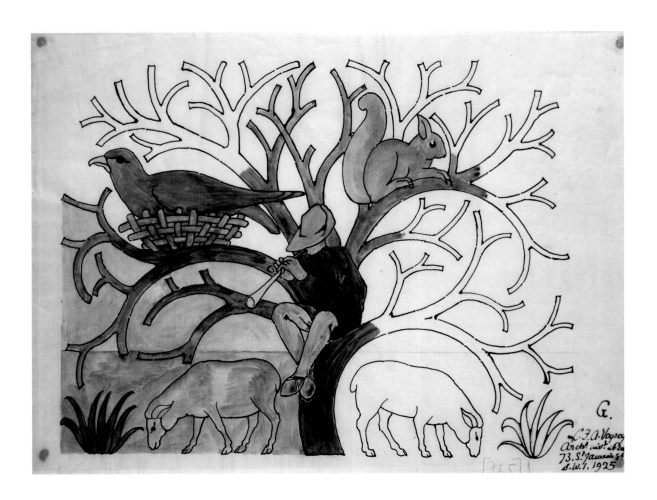

30. **Design for nursery textile, 1925**
Pen and colored washes on linen, 260 x 370 mm

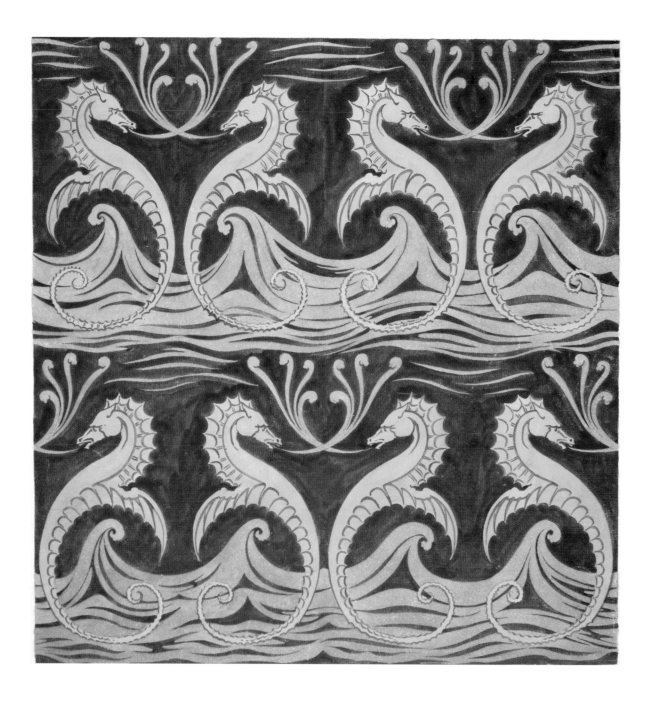

31. Design for a wallpaper or woven silk, c. 1887
Green and blue washes, 445 x 420 mm

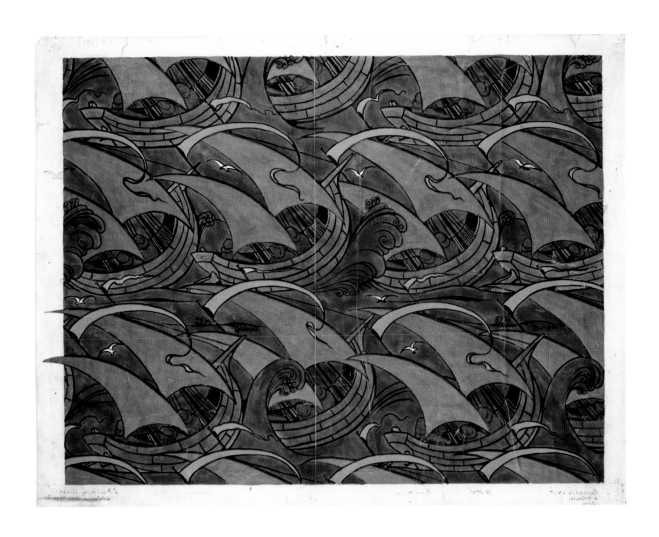

32. Design for a printed velvet called "The Three Men of Gotham," c. 1889
Yellow, brown, green, and blue body color and black ink, 555 x 725 mm

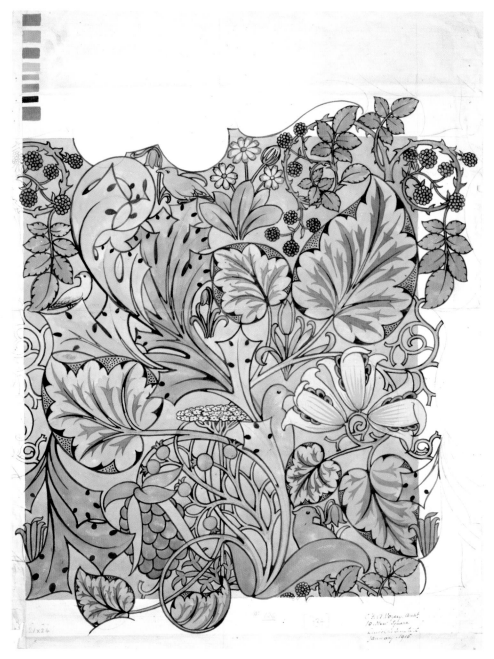

33. **Design for a textile or wallpaper, 1916**
Colored washes, 855 x 640 mm

"The life of animals might be made a source of stimulating joy in our own lives," Voysey wrote. "We all feel a sense of pleasure when the wild birds sing, and the idea of their love-making and aspiring and growing more good and useful every day is delightful, and ought to be recorded in our everyday articles of use."*

*Voysey, "Ideas," 124.

The Heart of the Matter
Individuality

Through nature or nurture, or both, C. F. A. Voysey inherited from his father a comprehensive spiritual worldview—and an uncompromising soul whose combative nature occasionally got the better of him. Even after the passage of forty years, he cherished the memory of an incident that arose in the 1880s, when John Pollard Seddon enlisted him to design a mosaic mural for Aberystwyth University.[59] Two years after the mural was completed, as an interviewer reported in 1927, part of one panel "was hurriedly pulled down by indignant authority which then for the first time discerned the true meaning of the symbolism employed in it, which represented Science tearing down Sacerdotalism"[60]—the belief that priests are needed as mediators between God and humankind, one of the Anglican doctrines the Reverend Voysey found most objectionable. "The glee with which Voysey recalls this exploit," the writer commented, "ignores the discomfiture of the learned dons on finding the decoration they had bought and paid for had been grimacing at them behind their backs for two years." (It also ignores the inappropriateness of a designer's undermining his clients—not to mention Seddon—by supplying work he must have suspected would be contrary to their wishes.)

The interviewer went on to say that because Voysey's "conscience would not allow him to lend himself to perpetuating tenets which he abhorred . . . he has never designed a Church; he would consider it flagrant hypocrisy in him to do so, unless he believed in the symbolism to be embodied in it." But it could be said that Voysey designed a church every time he set to work on a new house, for he saw the act of design as a spiritual undertaking in itself, and the products thereof as spiritual messages that could be read by those who were receptive.

Voysey laid out this view many times in sermonlike lectures and articles, most fully in the volume *Individuality*, published in 1915.[61] He opened the book with the premise that is the key to understanding his life and work: "Let us assume that there is a beneficent and omnipotent controlling power that is perfectly good and perfectly loving; and that our existence here, is for the purpose of growing individual characters." *Growing* is a carefully chosen word, for according

to Voysey, humankind has the potential to progress infinitely far in "moral and spiritual insight," evolving, in a sense similar to the physical process explained by Darwin, toward an ever "nobler and purer" appreciation of the Creator's "majesty and benevolence."

As Voysey explained it, every human being shares universal moral qualities—"reverence, love, justice, mercy, honesty, candour, generosity, humility, loyalty, order" and the like—but in varying degrees; these variations are what make us individuals with different thoughts and feelings. And because we are different, we can glimpse and communicate to each other new possibilities for development of these qualities. Take reverence, for example: we can look at a tree and feel "our own sense of reverence for Nature's Master." But if an artist can portray a tree for us in a way that will "awaken within our breast the songs of praise he has felt," then he increases our capacity for reverence and "stimulate[s] our higher nature." A different moral quality, a strong love of truth, might lead a designer to

gather his knowledge of form by making careful diagrams of flowers and plants[;] by drawing plans and elevations and sections, he will learn the true form of every part, with its structural relation of parts . . . in a way quite impossible, if he were to set the flower in a vase before him, and draw it as seen in perspective, which is the usual method . . .

The desire for truth thus leads to the accurate acquisition of knowledge that will help in the expression of other qualities, such as order, dignity, reticence, control, grace, and rhythm . . . harmony, sympathy, candour and loyalty. We learn in this way the interdependence of parts . . . Such knowledge stimulates the power of conceiving combinations of forms, in the mind's eye, and this creative power is the harbinger of progress, and the spirit that draws men up and on out of sloth and materialism into spiritual activity.

. . . When this knowledge is stored in the mind, individuality has its opportunity of expressing afresh the facts so gleaned, together with individual emphasis of particular sentiments.

A reverent mind stored with knowledge gleaned in this way, from Nature at first hand, cannot fail to have a refining influence on others, particularly if his energies be applied to objects of daily life.

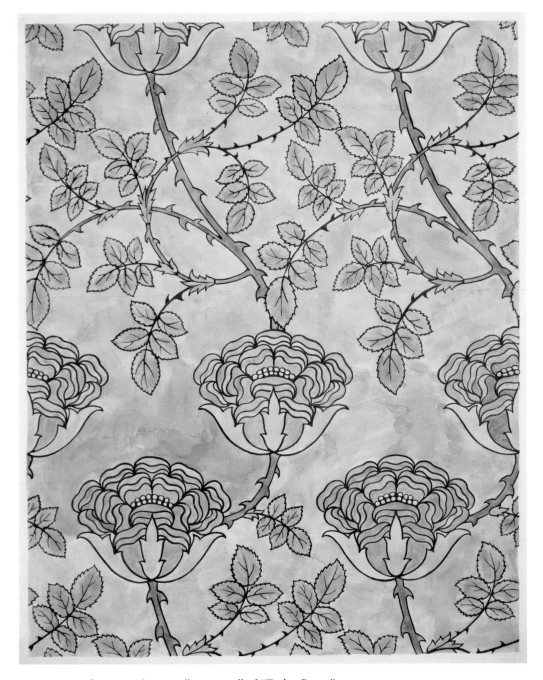

34. Design for a textile or wallpaper called "Tudor Rose," 1926
Ink and colored washes, 720 x 580 mm

Deeply committed to finding inspiration in the natural world, and to celebrating the character and climate of his own time and place rather than imitating foreign precedents, Voysey turned again and again to that most English of flowers, the rose. Here he invokes both the hedgerow flower and the heraldic emblem, adding interest through a nontraditional palette.

The theme of influencing others through the objects we create is something Voysey mentioned many times—in the 1909 lecture "Ideas in Things," for instance, where he also brought in individualism's chief enemy, collectivism:

> We may make doors and windows, chairs and tables with mechanical exactness . . . but neither we nor those who pay for [them] will gain any spiritual benefit from our labour unless we have put our hearts and minds into our work, anxiously seeking to impart some good thought or healthy feeling . . . But now the idea that a chair or table can be made to express thought and feeling seems to our workmen quite ridiculous. Their thoughts are directed to collectivists' visions, votes, and public control of property.[62]

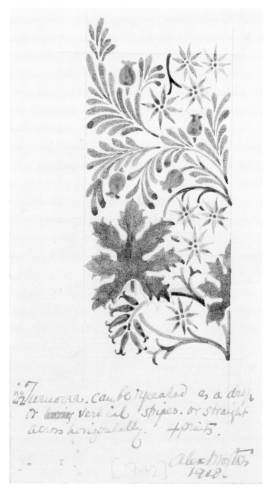

The "collectivists' visions" referred to here are aspects of socialism, which Morris and many other British Arts and Crafts proponents supported. But, to Voysey, collectivism came in many other guises—for instance, town planning ordinances, which often prescribed one-size-fits-all approaches that did not make sense in many cases. Whatever the shape, Voysey wrote, "collectivism, convention, and fashion, all derive their power through the suppression of the individual . . . Collectivism is a form of compulsion that cannot have the same

35. Sketch for a textile, for Alexander Morton, 1918
Pencil on tracing paper, approx. 400 x 295 mm

Voysey's patterns reflect his continual, careful observation of the English countryside. "What we need is more reverent study of nature and nature's ways. The effect on the human mind of watching and tracing out the operations of nature is of untold value. It humbles a man and softens his judgments of his brother; it quickens all that is best in our characters. The more we look into nature, the more we feel the spiritual forces behind us all. It is this perpetual attention to the spirit in its purest manifestation that will improve our work, and so increase our happiness and usefulness."*

*Voysey, "Ideas," 115.

ethical value and effect on character that individual free choice must always have."

Collectivism lurked in architecture as well—particularly in any form of classicism, with its formulaic proportions and its demand that a building be "made to fit a conception of a more or less symmetrical elevation . . . The design is conceived from the outside of the building and worked inwards. Windows are made of a size necessary to the pleasant massing of the elevation, rather than to fit the size and shape of rooms."[63] What Voysey called "the Gothic principle" worked in just the opposite way: "Outside appearances are evolved from internal fundamental conditions; staircases and windows come where most convenient for use. All openings are proportioned to the various parts to which they apply."[64]

> We must clear our minds of all conceptions of symmetrical elevations, made after the likeness of [ancient Greek] temples, and return to the Gothic principle of evolving our homes out of local conditions and requirements . . . The classical idol has reigned long enough; it must be cast out, because it is a false expression of our climate and character . . . Man's habits, customs, conditions and ideas have entirely changed . . . We must shake off the fashionable convention of obedience to style, and dare to be sincerely ourselves.[65]

A return to the Gothic principle, however, emphatically did not mean reproducing existing medieval buildings or even specific decorative details. To copy these was as bad as to copy from the Greeks (or anybody else). "Any revivalism must involve the sacrifice of fitness," Voysey warned.

> We should evolve our creations out of a due consideration of conditions and requirements, instead of imitating tradition or well-beloved examples, [because] our conditions and requirements are always changing; new methods and new materials are constantly being evolved, and men's habits and tastes are for ever developing. What suited people of the last century is not quite in tune with the feelings and needs of our own time.[66]

Moreover, imitation of an architectural precedent was—like making a realistic perspective drawing of a flower—an empty exercise: "We imitate . . . rather than

take the trouble to think for ourselves."[67] Voysey repeatedly referred to imitation as "ape-like" or "apish"—that is, a less evolved activity than that of applying intellectual and spiritual energy to a fresh act of creation. And it was only through investing such energy, after all, that an architect, designer, or craftsman could produce a building or object that would stimulate moral qualities in himself and others, moving the human race forward.

As a designer of houses, Voysey saw his role in very specific terms. "Supposing we are agreed in the belief that the highest developments of character are only possible under peaceful and simple conditions of mind, that war and turmoil are only the extreme conditions of a want of repose and simplicity," he wrote. "Then it is obvious that the home should be the most peaceful, restful, simple servant we possess. And we will run our thoughts over the whole place to see wherein ideas in harmony with and conducive to these feelings can be reasonably manifested."[68]

And "run his thoughts over the whole place" he did: every inch of a Voysey house received the benefit of his ingenuity, imagination, and care. He added no element to a design without a reason—a reason that might be practical, spiritual, or both, and which was often inspired by contemplation of the natural world. For instance, noting that nature provides a smooth horizon as if to steady the eye against the endless movement of the ocean,[69] Voysey sought to establish a similar feeling of repose by emphasizing horizontal lines—sweeping rooflines, long bands of windows, low ceilings—in his architecture. Reducing ornamentation also contributed to this sense of repose, although the rule did not necessarily mean eliminating decoration altogether. Carvings and moldings added to the cost of a house, and too often provided only "innumerable crevices and ledges for dust" and "wasted labour" in keeping them clean. Used judiciously, however, "mouldings and panellings . . . arouse the sense of grace, proportion, dignity, delicacy or greater fitness"—moral qualities as important as repose, and complementary to it.[70]

36. **Pattern design honoring Queen Victoria's Diamond Jubilee, 1897**
Blue, green, yellow, and orange washes on linen, 940 x 805 mm

Voysey's patterns were painstakingly composed to reflect his principles. Even a pattern as complex as this one, produced as a wallpaper by Essex & Co. and as a tapestry by Alexander Morton & Co., could contribute to the restful feeling he felt was essential to a home. "You will find in all my designs," Voysey wrote to James Morton of the Alexander Morton firm, "a clearly marked contrast between the small, rich, intricate or elaborate parts of the design and the plain simple bare pieces. This . . . produces breadth—Breadth is on the side of simplicity and repose."*

*Jocelyn Morton, *Three Generations in a Family Textile Firm* (London, 1971), 95, quoted in Haslam, "Carpet Designs," 406-408.

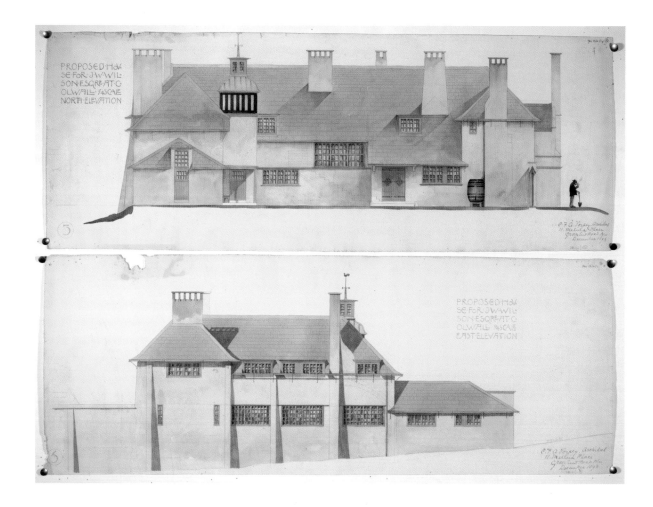

37. Two designs for Perrycroft, Colwall, Herefordshire, for J. W. Wilson, c. 1893
Pencil and colored wash, both 285 x 775 mm

"If we cast behind us all preconceived styles," Voysey declared, "[our work] will be a living natural and true expression of modern needs and ideals: not an insincere imitation of other nations or times."* Depicted here and on the next two pages are designs for Perrycroft, Colwall, Herefordshire (c. 1893); Hill Close, Studland, Dorset (1896); and Annesley Lodge, Hampstead, London, completed in 1897 for Voysey's father, the Reverend Charles Voysey—all products of this philosophy.

*Voysey, *Individuality*, 62.

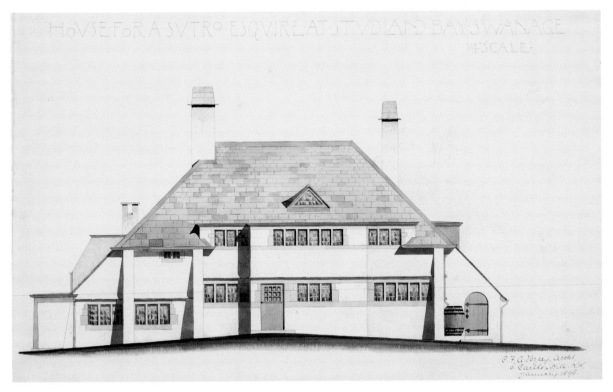

38. Design for Hill Close, Studland Bay, Studland, Dorset, 1896
Watercolor, 390 x 570 mm

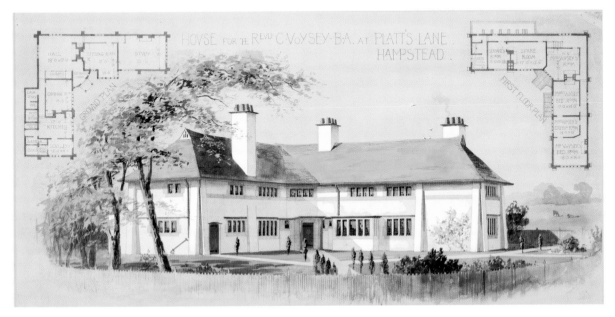

39. Design for Annesley Lodge, Platts Lane, Hampstead, London, 1895
Watercolor, 336 x 615 mm

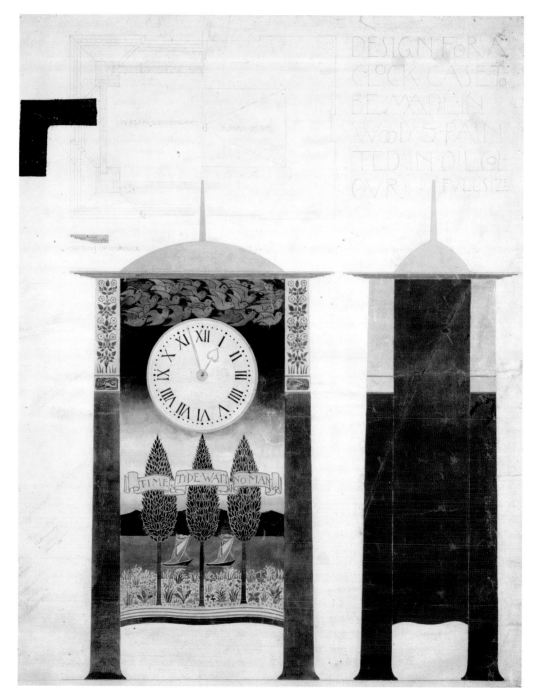

40. Design for a clock case to be made in wood and painted in oil color, 1895
Pencil, watercolor, and gold paint, 785 x 560 mm

Voysey designed and decorated this wooden clock for his own use. At The Orchard, it was displayed in prime position at the center of the hall mantel (fig. 44).

At Home with Mr. Voysey

Interiors, Furniture, Metalwork

In 1899 Voysey built a home for his family at Chorleywood, near London. Though it was more modest than many of his commissioned houses, The Orchard (figs. 41–46) became a showplace for its owner's work and ideas. Interior and exterior were photographed not just for English periodicals, but also for Charles Holme's *Modern British Domestic Architecture and Decoration*, Hermann Muthesius's *Das Englische Haus* and *Das Moderne Landhaus*, and the American magazine *The Craftsman*.

In his autobiography, the South African writer William Plomer described another Voysey house, Lowicks (1894), in terms that could apply just as well to The Orchard, at least as Voysey presented it in photographs. Lowicks, Plomer wrote, was

> beguiling and . . . idiosyncratic, partly because everything was very high or very low. The roof, for instance, came down steeply almost to the ground; the casement windows were wide and low and the window seats very low; but the latches on the doors were very high and to open them one had to make a gesture like one proposing a toast; straight and very high were the backs of the chairs which . . . were pierced with heart-shaped openings; on high shelves near the ceilings stood vases of crafty green pottery filled with peacocks' feathers; and the hot water cans, coal-scuttles, electroliers and so on were made of beaten or hammered brass or copper. It was . . . the last word, or at any rate the last but one, in modern taste and comfort.[71]

Voysey wrote about The Orchard in *Architectural Review*, cataloguing the plants and animals that populated the grounds with the same fond precision he brought to his pattern designs:

> high hedges, interspersed with holly bushes . . . cowslips, primroses, buttercups, snowdrops, violets, orchis, and honeysuckle grow wild in their

season . . . Nightingales, larks, linnets, thrushes, blackbirds, wood pigeons, and even foxes, deign to keep company with the little house.[72]

Characteristically, he also took a swipe at intrusive "collectivist" planning ordinances: "Only the stupid local bylaws prevented the soil-pipe being carried through the two w.c.'s in a straight run to the drain; as it is, they had to be twisted and turned to the outside of the wall, thanks to the unpractical theorists who frame these regulations."[73]

Many elements that became standard parts of the Voysey design vocabulary can be seen in The Orchard's interiors. Narrow strap hinges emphasize the width of his batten doors, which Voysey deliberately made "wide in proportion to height, to suggest welcome—not stand-offishly dignified, like the coffin-lid, high and narrow for the entrance of one body only."[74] The ceilings are "only eight feet high, and with their deep white frieze have an abundance of reflecting surface."[75] At the time, of course, most clients wanted their ceilings lofty, and Voysey continually argued against the idea:

Because we are seeking to produce the feeling of repose, low rooms will help us greatly, and give us the benefit of reflected light, and allow of smaller windows . . . [which], when rightly placed, in conjunction with white ceilings and friezes, may produce very light rooms, and have the advantage of preserving equable temperature throughout the year. You will so save me the expense of elaborate blinds and curtains, and give me all the sun I need without the scorching or glare on the hottest summer days; again simplifying not only the furnishing of my rooms, but the cleaning and warming of them.[76]

41. Perspective drawing of The Orchard, from Charles Holme's *Modern British Domestic Architecture and Decoration* (1901).

42. Elevation drawing of The Orchard, from *Modern British Domestic Architecture and Decoration* (1901).

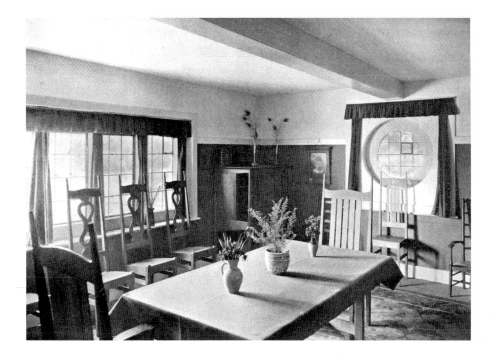

43. These views of The Orchard's dining room appeared in *Modern British Domestic Architecture and Decoration* (1901). The room looks staid in the photograph, but the watercolor view from the hall brings the house alive with Voysey's choice of rich tones. He advised looking to the natural world for guidance in combining color: here the palette reflects his description of springtime, when nature "feasts us with delicate greens, greys, blues, purples"; red, which nature uses "most sparingly" of all the colors, makes an appearance in the simple window curtains.* Photographs courtesy of author.

*Voysey, "Ideas in Things," 117.

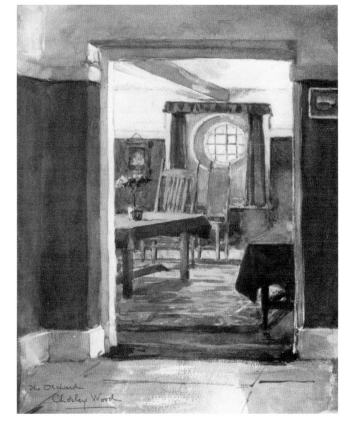

44. The hall at The Orchard was simply yet comfortably furnished with Voysey pieces in unstained, unpolished oak. A purple silk fiber wallpaper, Turkey-red curtains, a rug of muted blue-green, and a few chosen ornaments provided richness without clutter. Voysey warned readers of *The Studio* in September 1893 that "in most modern drawing-rooms confusion is the first thing that strikes one. Nowhere is there breadth, dignity, repose, or true richness of effect, but a symbolism of money alone. Hoarding pretty things together is more often a sign of vanity and vain-glory than of good taste . . . Let us begin by discarding the mass of useless ornaments and banishing the millinery that degrades our furniture and fittings. Reduce the variety of patterns and colours in a room. Eschew all imitations [of costly materials], and have each thing the best of its sort, so that the decorative value of each will stand forth with increased power and charm."

Note the wooden clock (fig. 40) on the hall mantel.

45. One of Voysey's own papers decorated his study at The Orchard. Set into the wall above the fireplace is the ventilator grille that he designed and commonly used in his houses. Voysey frequently spoke of the benefits of healthy air circulation and uniform temperatures, priding himself on the techniques he had developed. Photograph from *Modern British Domestic Architecture and Decoration* (1901).

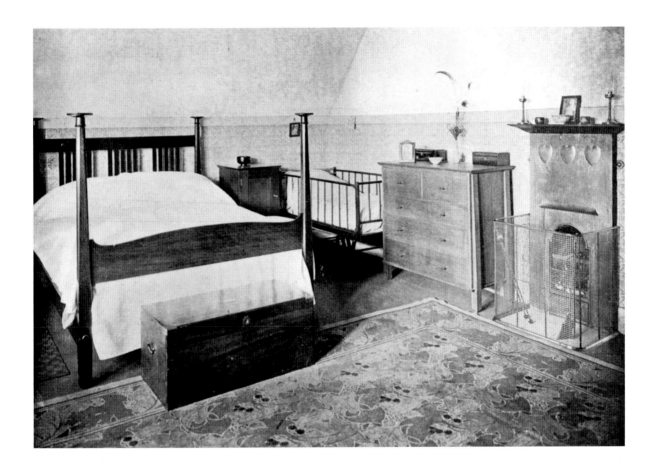

46. This bedroom at The Orchard was furnished from carpet to cast-iron chimneypiece with Voysey designs. Like the study, the bedrooms were hung with Voysey papers; the children's playroom featured his "Squire's Garden" design (fig. 61). Photograph from *Modern British Domestic Architecture and Decoration* (1901).

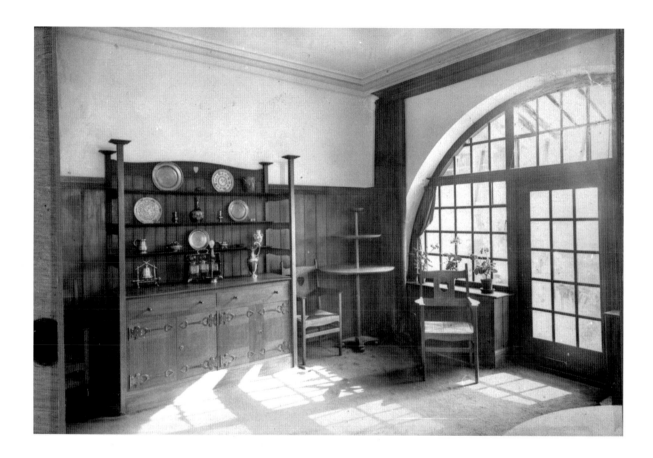

47. This dresser, part of the dining room redecoration at 37 Bidston Road, Birkenhead (1902), is identical to or very like four others for different clients.* The high corner posts with flat caps are often seen in Voysey's furniture; he adapted them from the slim columns A. H. Mackmurdo used for a booth at the Liverpool International Exhibition, 1886. The pierced strap hinges were probably chosen from the range of hardware Voysey created for Thomas Elsley & Co. Convinced that "depraved coarseness, brutality, and sickly elaboration characterise the metalwork on nearly all modern furniture,"† Voysey designed his own. Some pieces were craftsman-made, but once Elsley & Co. brought out their Voysey line, he often simply indicated the desired Elsley stock numbers on his drawings for homes or furniture.

The straightforward forms found in Voysey's furniture reflect his recognition that, while he might prefer handcraftsmanship, the use of mechanical aids was almost unavoidable. "Think of the machine that is going to help in the making," he urged in "Ideas in Things" (1909), "and choose such shapes as are easily worked by machinery . . . [Y]our wood comes to you machine-sawn and machine-planed, and the only thought and feeling you can put into your furniture must be through a mechanical medium. So right proportions and the natural qualities of the wood, the suitable colour and texture of the upholstery make up your limited vocabulary."

*Symonds, *C.F.A. Voysey*, 61, entry number 339.
†Voysey, "Domestic Furniture," 41.

49. In his lecture "The English Home," Voysey scolded designers for creating overdecorated

48. The central hinge of this cabinet, pictured in *The Studio* of May 1896, was pierced with a design of a shepherd family walking among trees in which birds are perched. In 1897 the magazine praised Voysey's furniture for its simplicity:

> One sees . . . no reliance on mouldings or machine carvings, ormolu mountings, or other 'stuck on' decorations; but all the same in hinges, escutcheons, and other portions where ornament can be used wisely, he does not shun it, but rather welcomes and amplifies it so that these few portions impact the effect of sumptuous adornment to the whole of a structure that else relies solely on good material, shaped to fine proportion.

modern fireplaces . . . surrounded by glazed earthenware, cast, wrought, dull, polished iron, brass or copper, then marbles and wood all at war with each other for the glory of attracting the most attention, and disturbing the peaceful reflections of the householder. The burning wood or coal is our congenial friend, that sheds a warm glow over our affections; let us raise him up as we do the Host, and do honour to him by putting around him a suitable frame; but do not forget that the frame exists only for the picture.

Whether designing fireplaces in marble for his grander houses, in tile for more ordinary homes, or in cast iron for sale through the Elsley & Co. catalog, Voysey kept the setting plain so that the fire remained the focus. The iron chimneypiece and grate shown here were pictured in Hermann Muthesius's *Das Englische Haus* (1904).

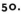

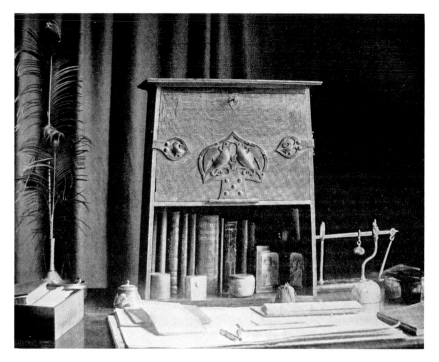

50.

50, 51, 52. Voysey produced several variations on this table-top bookcase/stationery cabinet. Figure 50, published in *The Studio* in 1896, appears to be made of oak with wrought metal hardware. Figure 51 (whose back is shown in fig. 52), from the American magazine *The Craftsman* (August 1903), was in white holly with inlaid decoration. "It was imported by Mr. Gustav Stickley, and shown in the Arts and Crafts Exhibition which was held in March last, in the Craftsman Building, Syracuse, N.Y. . . . The birds are really masterpieces; the little black blocks of which they are composed rendering the action of the raven in a perfection that is wonderful in view of the simple means employed."

Photographs courtesy of author

51.

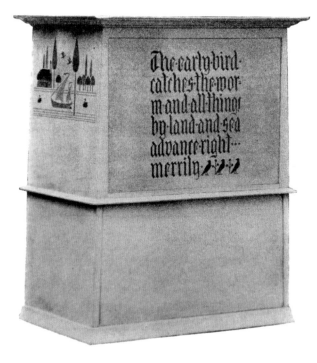

52.

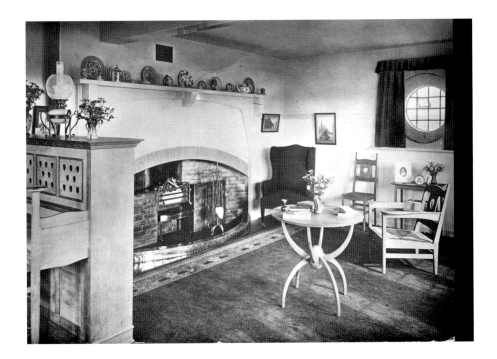

53. For the parlor at Holly Mount in Buckingham-shire (1905), Voysey used the same low, beamed ceiling, ventilation grille, bull's-eye window, and oil lamp (far left) as for The Orchard. The cottage piano case is by Voysey, as is the unusual round table, designed in 1903 to be "made without nails or screws" (fig. 54).

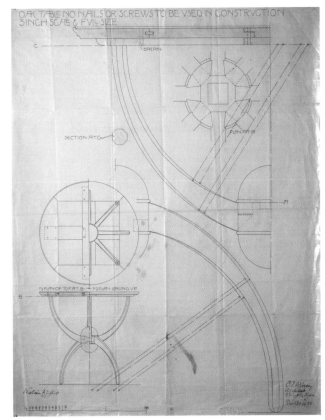

54. Design for an oak table, 1903
Ink on linen, 600 x 752 mm

SYMBOLISM

Voysey's home furnishings and patterns are replete with symbols—a sort of shorthand he used to convey certain thoughts or feelings. Sometimes the meanings assigned are traditional. His pattern "Fidelis" (fig. 55) refers to the legend that, in times of famine, the pelican will sacrifice herself for her young, piercing her breast with her beak so as to feed them with her own blood. "Halcyone" (fig. 56) depicts the figure from Greek myth who drowned herself in the sea and was resurrected as a kingfisher, with the ability to calm the waves and so make her nest upon them. Often, however, the meaning seems to have been much more individual: to Voysey the eagle, because it flies highest and therefore sees farthest, stood for aspiration, revelation, and "the heavenward quest," while the vulture—perhaps because it clears the world of carrion—was as much a symbol of purity as the lily (fig. 57).[77]

Voysey used the heart, indicating "the emotions and affections," more than any other device; more than once—as on his personal bookplate, or "The Union of Hearts" design (fig. 58)—he surmounted it with a crown. This was a token not of power but of self-discipline, since crowns, he wrote, were originally worn "to symbolise self-control by the binding round, controlling, and confining of the head with a band or ring."[78] Hearts appear not only in Voysey's graphic designs but worked into his buildings, furniture, and metalwork as well (see fig. 69). He created a heart-shaped letterbox for the main door of his own home, The Orchard (fig. 42), and for several other houses. "Voysey wanted to put a large heart-shaped letter plate on my front door," recalled one client, the novelist H. G. Wells, "but I protested at wearing my heart so conspicuously outside and we compromised."[79] Voysey inverted the heart, adding a stroke below as a handle, and the symbol became a spade, the old tool of the farmer or gardener, which Voysey called "the instrument by which material is made to fructify."[80]

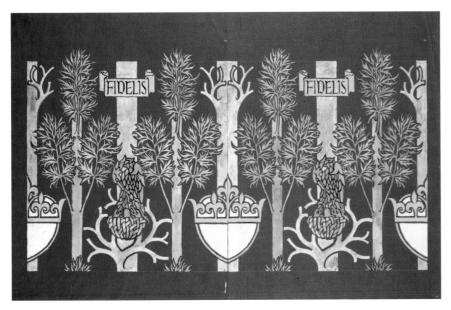

55. Design for a textile called "Fidelis," 1919
Inscribed "Symbol of self sacrifice" on the back
Blueprint with color added, 375 x 580 mm

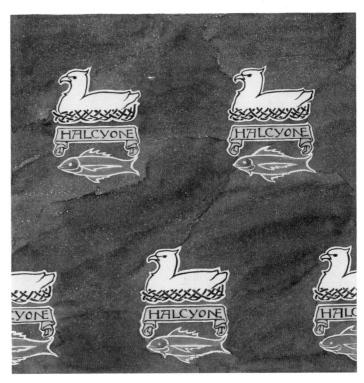

56. Design for a textile or wallpaper called "Halcyone," 1904
Yellow, brown, and blue washes with black ink, 345 x 330 mm

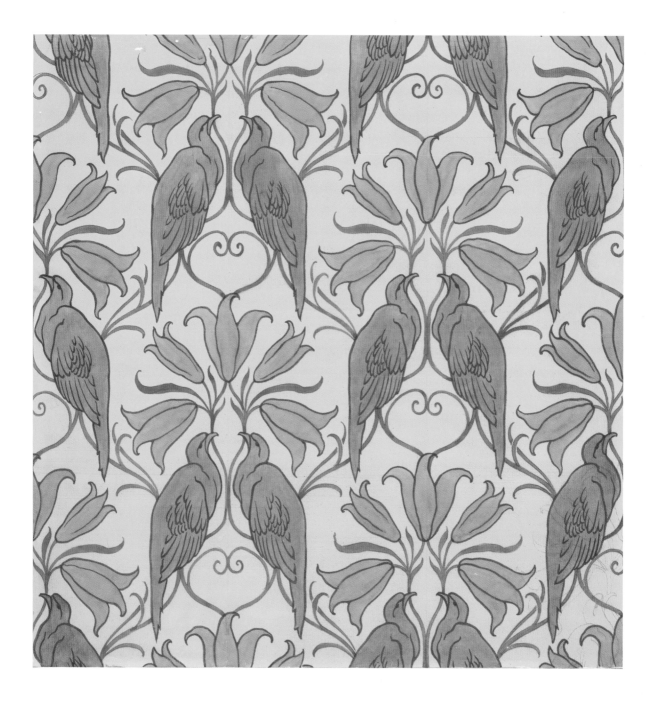

57. **Wallpaper design produced by Essex & Co., before 1899**
Inscribed "Vulture & lily symbols of purity" on the back
Yellow, green, pink, and orange washes, 405 x 390 mm

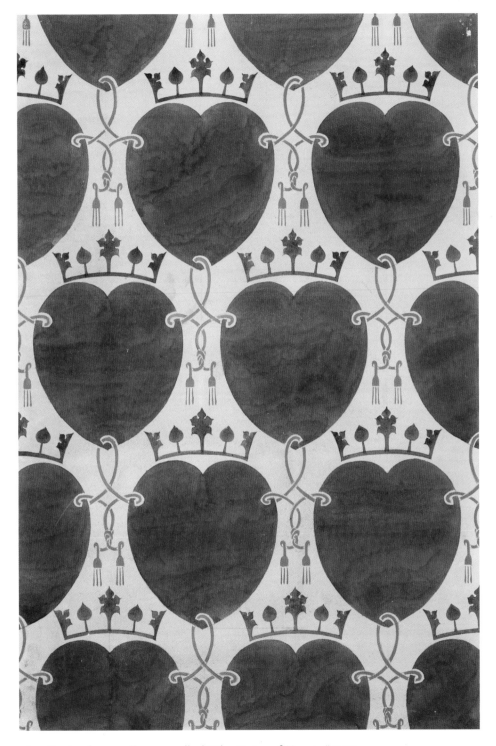

58. Design for a wallpaper called "The Union of Hearts," 1898
Colored washes, 510 x 340 mm

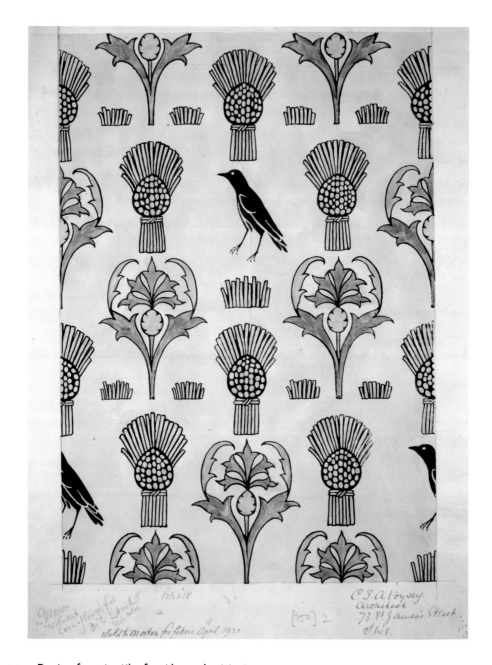

59. Design for a textile, for Alexander Morton, c. 1920
Colored washes, 540 x 380 mm

The meanings of Voysey's designs can be open to interpretation. Stuart Durant identifies the sheaf in this design as a traditional sign of plenty, and the crow of hope.* On the other hand, Voysey may simply have intended to evoke the English countryside at harvesttime, depicting stubble, sheaves, the cornflowers that are common to British wheatfields, and the crows that scavenge for grain.

*Durant, *Decorative Designs*, 78.

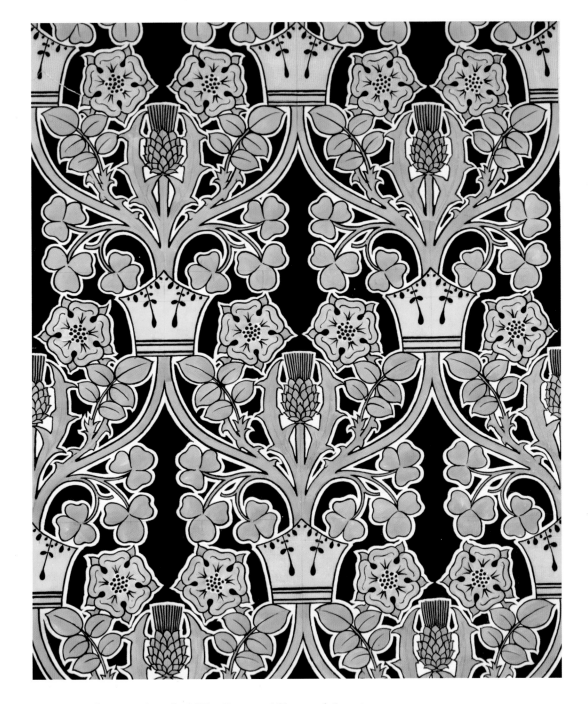

60. **Design for a textile called "The Rose and Shamrock," 1928**
Pencil and colored washes, 765 x 575 mm

This Rose and Shamrock design speaks to the unity of England (rose), Ireland (shamrock), and Scotland (thistle) under the rule of one monarch. For Voysey, the crown was less a symbol of pomp than of self-control and responsibility.

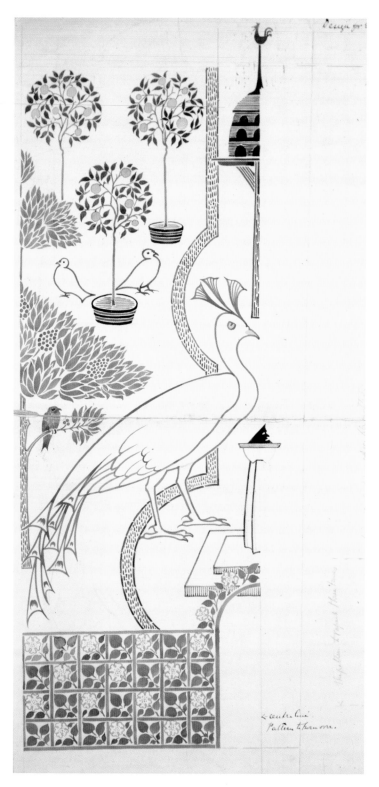

61. **Design for an embroidered quilt called "Squire's Garden," 1896**
Pencil and colored washes,
780 x 510 mm

A close look at "Squire's Garden," reveals a sundial whose gnomon takes the form of a grotesque profile. In the finished bedspread (displayed at the 1896 Arts and Crafts Exhibition and reproduced in *The Studio*, December 1896) and in a wallpaper manufactured from the same design, the gnomon has been simplified to a shark's-fin shape.

Humor and Grotesques

VOYSEY'S SPIRITUAL PHILOSOPHY suffused his life and work—but so did his sense of humor. It flashed out in his writings: "Cold vegetables are less harmful than ugly dish covers. One affects the body and the other affects the soul."[81] It turned up in his pattern designs; he even built it into his houses. He had a particular weakness for puns. Designs for his friend R. W. Essex, the founder of the wallpaper firm, included a bookplate and a garden plan, each built around the letters *SX* (fig. 62).[82] An undated wallpaper or textile design titled "Peace" alternates the letter *P* with a dove and olive branch (fig. 63), and "Great Kings and Queens" (1930) intersperses crowned heads with what is clearly the barred iron fire basket—the *grate*—of a fireplace (fig. 64). In "Let Us Prey," a 1909 fabric design in the Victoria and Albert Museum, Voysey turned to the food chain for inspiration, using flowing curves and cheerful colors to depict a cat, which stalks a bird, which stalks a caterpillar, which gnaws at the stem of a flower. The irony is similar to that of "I Love Little Pussy" (fig. 65), where the cat's interest in the garden's birds and mice undercuts the sugary sentiment of the nursery rhyme.

A visitor to a Voysey house, savoring the calming influence of its uncluttered interiors and natural finishes, might suddenly come eye to eye with something unexpected yet still quintessentially Voysey: a grotesque mask, or a wickedly cheerful demonic profile, often sticking out its tongue at the passing world. Voysey referred to these comic faces in one of his lectures: "A feeling for simplicity and restfulness will result in economy of labour and material, and perhaps leave us with a little spare cash to devote to one spot of sculpture, one point of pre-eminent interest in which we might suggest some merriment like the old grotesques."[83] Such masks might take the visitor by surprise, but they are not out of place. Voysey's buildings are simple but never sterile, and he felt that laughter was part of any healthy home.

Voysey's use of comic faces goes back to his earliest solo commission, the Lakin cottage (1888), where a small metal grotesque adorns each bedroom door.[84] Similar whimsical details appear in many subsequent Voysey homes. Designs for the Bedford Park house (1891; fig. 66) show carved anthropomorphic

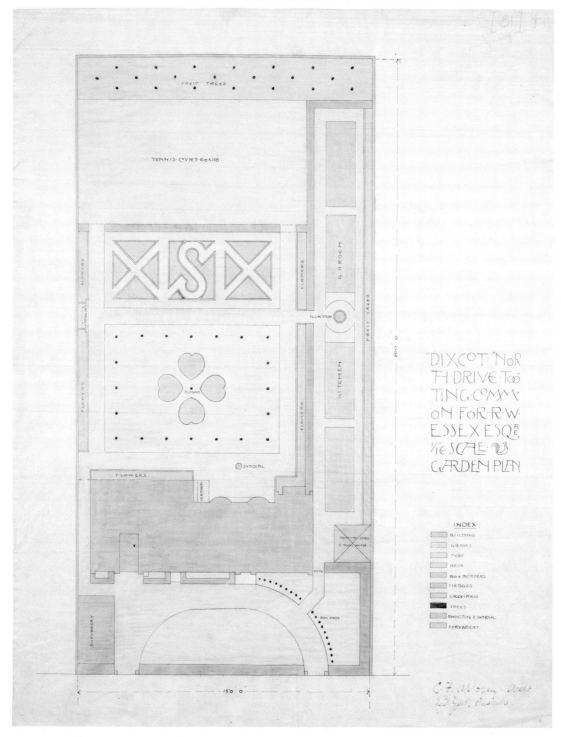

62. Garden plan for R. W. Essex, at Dixcot, Tooting Bec Common, London, c. 1898
On linen, 555 x 440 mm

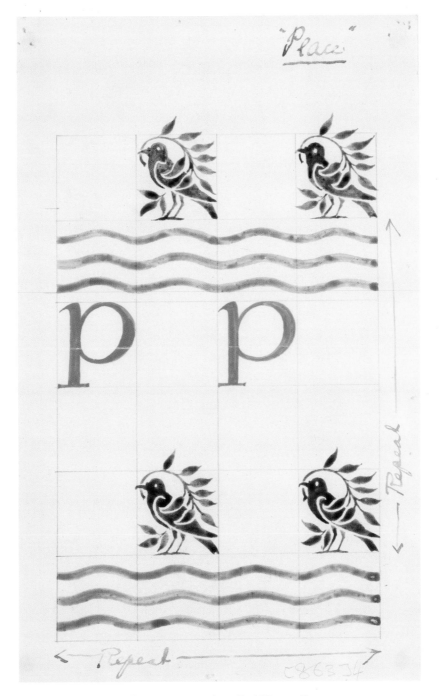

63. Design for a wallpaper or textile called "Peace," c. 1918
Pencil sketch composed of 1" squares, 392 x 404 mm

According to Stuart Durant, the "Peace" design probably dates from 1918 and marks the end of World War I.*

*Durant, *Decorative Designs*, 75.

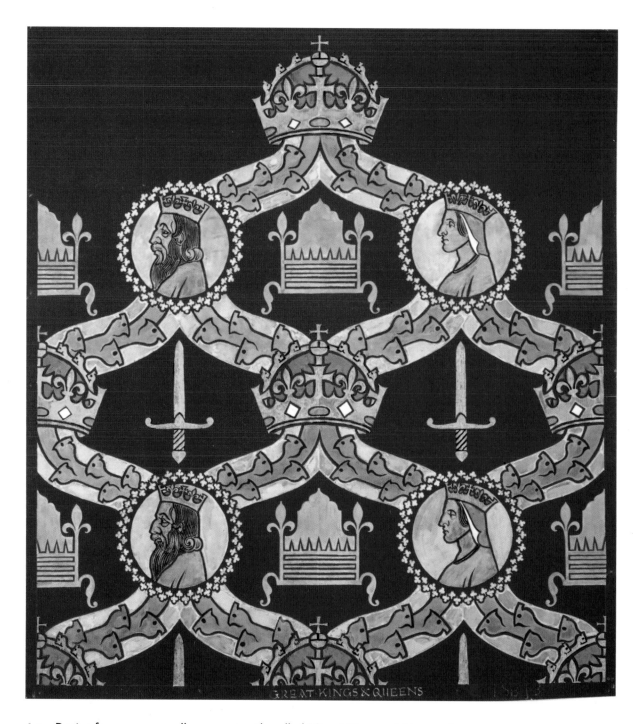

64. Design for a nursery wallpaper or textile called "Great Kings and Queens," 1930
Blue print with watercolor washes, 505 x 455 mm

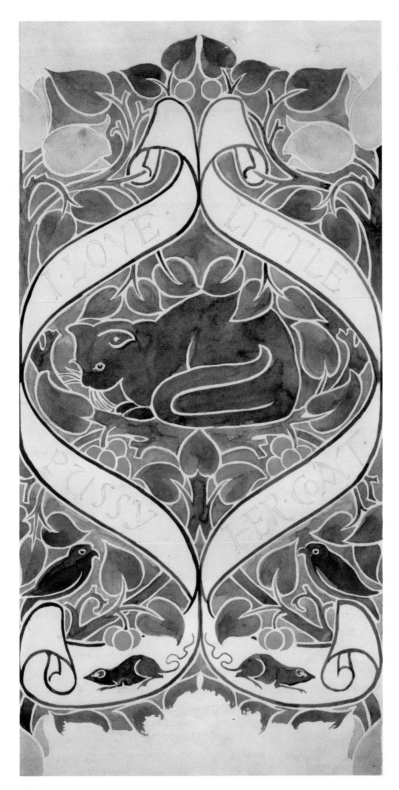

65. Design for a wallpaper or textile called "I Love Little Pussy," c. 1898 or 1908

Pencil and colored washes, 555 x 300 mm

corbels smirking from beneath a mantelshelf, and the exterior perspective sketch and elevations show that the porch corbels received a similar treatment.[85] The porch of another 1891 house, a studio for the artist W. E. F. Britten, is supported by a pair of flat cutouts showing a human profile—possibly Voysey's own.[86] The idea of incorporating the architect's image in a house was certainly nothing new; indeed, at this same time, the American Richard Morris Hunt was enshrining his own portrait prominently amid the bronze and marble reliefs of sumptuous Vanderbilt mansions. But it was typical of Voysey to reduce the form to a modest silhouette, and to give it a job to do beyond mere decoration. Other comic profiles appear in a row supporting an oriel window at Perrycroft (1893); hold up the porch at New Place (1897; figs. 75, 76); and form bases for sundials at Britten's studio (fig. 67) and at Norney (1897).[87] In some cases, the faces may have emerged simply from Voysey's fertile imagination; in others they may have caricatured a client. Voysey's notes on drawings for the carved beam-ends in the Hall

66. Sketches for fireplace corbels at 14 South Parade, Bedford Park, London, published in *The British Architect* in 1891

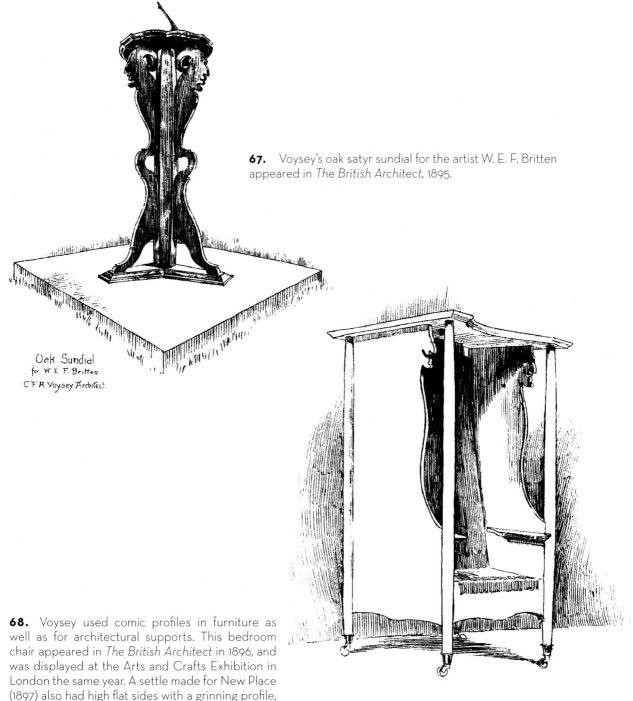

Oak Sundial
for W. E. F. Britten
C. F. A. Voysey Architect.

Bedroom Chair
by
C. F. A. Voysey

67. Voysey's oak satyr sundial for the artist W. E. F. Britten appeared in *The British Architect*, 1895.

68. Voysey used comic profiles in furniture as well as for architectural supports. This bedroom chair appeared in *The British Architect* in 1896, and was displayed at the Arts and Crafts Exhibition in London the same year. A settle made for New Place (1897) also had high flat sides with a grinning profile, as shown in a period photograph.*

*Reference number 20390/3, RIBA Library Photographs Collection. Viewable online as number RIBA11148, RIBApix online image database, http://www.ribapix.com.

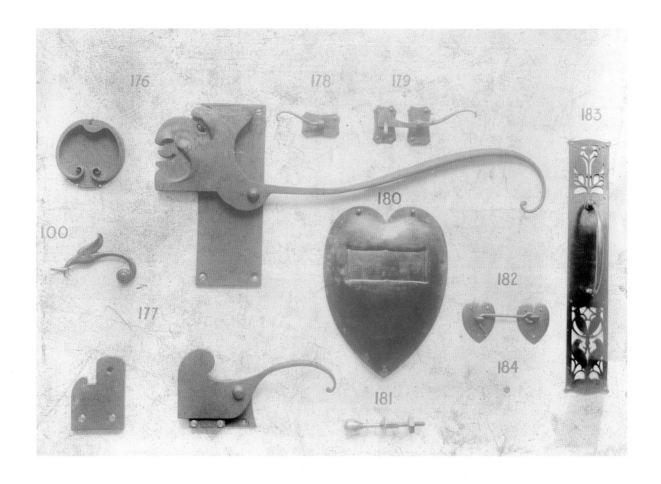

69. This display of Voysey-designed Thomas Elsley & Co. hardware features a grotesque latch very like one he designed for the entrance gate at Moorcrag (1898).*

*Symonds, *C.F.A. Voysey*, Fig. 66.

at Broadleys (1898; fig. 72) suggest that there he was trying to catch a particular likeness: "This nose," he instructed, "must be sharp cut with its true fascits [sic] and not to be round and dumpling shaped."[88]

Scholars have puzzled over Voysey's 1889 pattern "The Demon" (fig. 70). "Did Voysey seriously imagine that an early wallpaper covered with fearsome, fire-breathing devils would be saleable to any but the most eccentric of manufacturers?" asks the design historian Stuart Durant.[89] Perhaps not; in fact, the heretical clergyman's son may have created the diabolical design as a more or less private jab at the pious complacency of the religious mainstream. Four years before, after all, he had inserted his subversive symbols into the Aberystwyth mosaic. And in the same year as "The Demon," he created a design that seems to fall into a similar category: a pattern of tiny, energetic devils (Theists?) buzzing like wasps around much larger angels (the established church?), whose expressions seem serene but whose stiffly folded arms and wings suggest unease and hint at a stubborn resistance to change (fig. 71).

Voysey occasionally portrayed himself and those dear to him in lighthearted religious guise, heavenly or otherwise. He once drew his wife, Mary Maria, as the biblical Mary: robed, crowned, and holding their infant daughter, with their sons as angels at her side.[90] Around 1900 he sculpted himself as a gleeful "Architect's Devil," complete with horns, tail, cloven hooves, and extended tongue.[91] It's possible that the devilish faces in "The Demon" are self-portraits as well—or, alternatively, that they depict the man Voysey always acknowledged as his greatest influence. At the time of his expulsion from the Anglican Church, *Vanity Fair* caricatured the Reverend Charles Voysey in what must have been a typical pose—leaning forward to make a point, one hand shoved in his pocket, one knee on a chair, his shock of hair swept back from his broad forehead (fig. 7). The devilish figure in "The Demon" resembles the *Vanity Fair* cartoon in hair style and posture. It may be that "The Demon" is a sly comic tribute to Voysey's father—happily preaching from the pulpit of his new church, ignoring the hellfire that a literal-minded Anglican would consider his just deserts.

70. Design for a wallpaper or textile called "The Demon," 1889
Yellow, red, and green body color and black ink, 430 x 300 mm

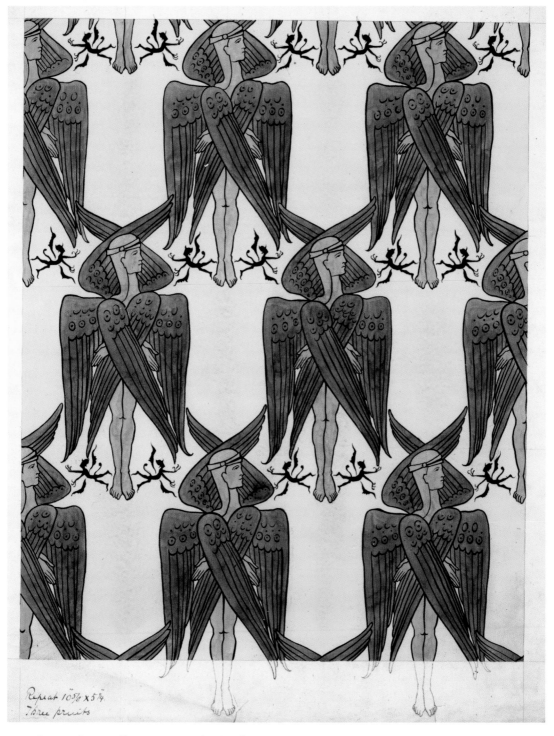

Repeat 10⅝ x 5¼.
Three prints

71. Design for a wallpaper or textile, April 1889
Colored washes and black ink, 490 x 410 mm

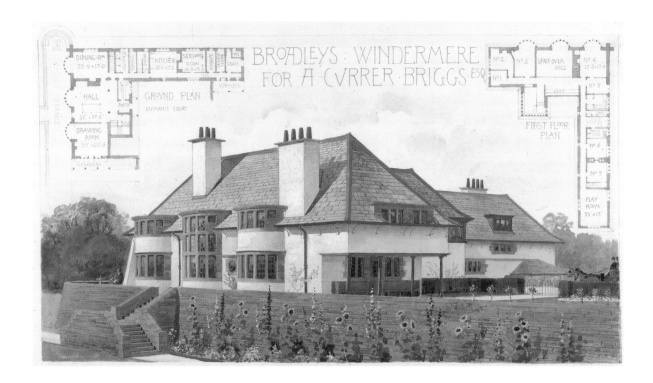

Within the drawing, the following inscriptions appear: BROADLEYS · WINDERMERE FOR A CVRRER BRIGGS ESQ; GROUND PLAN; FIRST FLOOR PLAN; DINING·RM 22·9×17·0; KITCHEN 16·6×17·0; SERVANTS ROOM 14·0×13·; WC COALS; HALL 35'×17·6; DRAWING ROOM 20'×20·6; VERANDAH; PLAY ROOM 23'×17'; SPACE OVER HALL

72. **Design for Broadleys (or Broad Leys), Lake Windermere, Westmoreland, for Arthur Currer Briggs, 1898**
Watercolor, 265 x 450 mm

Broadleys, on the shores of Lake Windermere in the Lake District, is acknowledged as one of Voysey's finest houses. It's also the only one that is regularly open to the public: the owners, the Windermere Motor Boat Racing Club, provide B&B accommodations when club members are not in residence (see www.wmbrc.co.uk).

Rise and Fall

Voysey began to hit his stride in the early 1890s. One reason for his success, as Wendy Hitchmough points out, was his adroit use of the press.[92] Advances in photography and printing meant that new magazines such as *The Studio* could bring the full spectrum of art, architecture, and design to an international readership—laymen as well as practitioners. From its first issues in 1893, *The Studio* brought Voysey exposure and, therefore, commissions, while its writers passed along his colorful comments on design. Voysey was among the first architects to routinely supply *The Studio* and other periodicals with crisp, professional, often daringly composed photographs of his architectural projects—artistic images that editors were eager to publish.

Such photographs made his houses "famous with the progressive architects all over Europe," wrote Nikolaus Pevsner in 1941, summing up Voysey's impact:

> "Broadleys" . . . for example, and "The Orchard" . . . and many others were illustrated in *The Studio* and *The British Architect* . . . in *Dekorative Kunst* and *Deutsche Kunst und Dekoration*. Muthesius's *Das Englische Haus* of 1904 contained the ultimate recognition of his European importance. Its influence on Mackintosh and Walton in the north is evident, that on Baillie Scott and Ashbee in the south hardly disputable; with Muthesius's help it created the so-called cottage-style in Germany and Holland; van de Velde said it appeared like Spring re-born to the young artists of Belgium, and Dudok in Amsterdam . . . called Voysey . . . England's greatest living architect.[93]

73. C. F. A. Voysey, c. 1910

In 1909 Francis Newberry, head of the prestigious Glasgow School of Art and an early mentor and teacher of Charles Rennie Mackintosh, offered Voysey the directorship of the school's decorative art department, but the architect could not be persuaded to leave London.[94] Voysey may sometimes have looked back with regret on this decision, for as luck and other factors would have it, his last house commission was completed two years later,

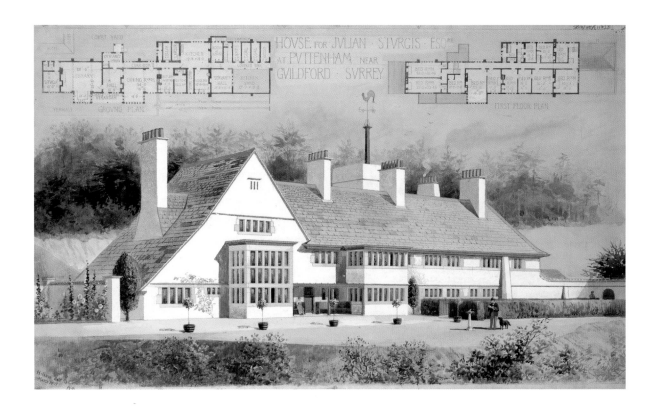

74. Design for a house known variously as Merlshanger, Wancote, and Greyfriars, The Hog's Back, Surrey, for Julian Sturgis, 1897
Watercolor, 400 x 695 mm

At Greyfriars, Voysey combined bold horizontals with a sweeping roofline punctuated by tall white chimneys.

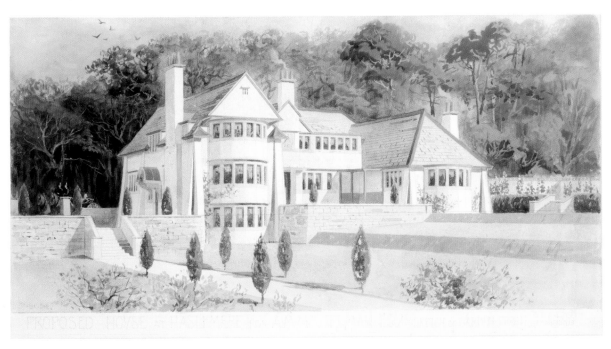

75. Design for Hurtmore, later called New Place, Farnham Lane, Haslemere, Surrey, 1897
Watercolor, 235 x 445 mm

New Place provided a sloping site that let Voysey play with levels and create a terraced garden.

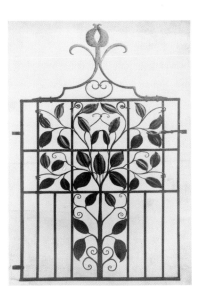

76. Gate for New Place, Haslemere, executed by W. B. Reynolds
of 7b Old Town, Clapham, London, 1901

One of Voysey's largest and most ambitious houses, New Place allowed for the use of fine materials and custom metalwork, including gates for the Voysey-designed garden.

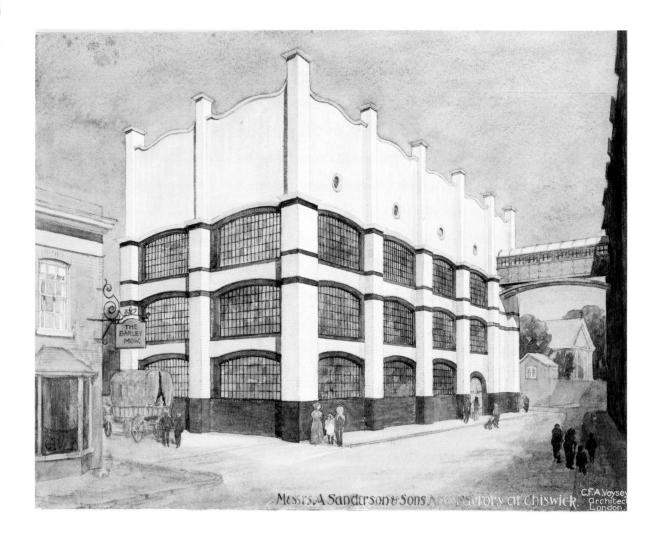

77. Design for Sanderson & Sons factory, Barley Mow Passage, London, 1902
Watercolor, backed with card, 230 x 295 mm

Voysey designed wallpapers for Sanderson & Sons; in 1902 he designed this extension to their factory in Chiswick, his only industrial building. The supporting piers, often likened to the tall columns on Voysey furniture (see figs. 46 and 47), also served as ventilation shafts. The walls were white-glazed brick striped with dark blue.

78. Voysey designed the interiors of the Essex and Suffolk Life Insurance Society's London offices in 1908. As he told *The Builder* in 1909, "We put in new windows, doors, fireplaces and floors, and furnished the offices; everything being designed by me, even the calendars, inkstands, pen-tray, &c. The principle we worked on was to have everything durable, and minimise the cleaning as much as possible . . . All the woodwork and furniture is in oak, left in its natural colour. The counters are gilded, with quarter-plate glass on top . . . [T]here are twenty-seven panels of stained glass representing the arms of towns in which the Society does business."*

The Builder XCVII (1909): 466, quoted in Brandon-Jones and others, *C.F.A. Voysey.* 63.

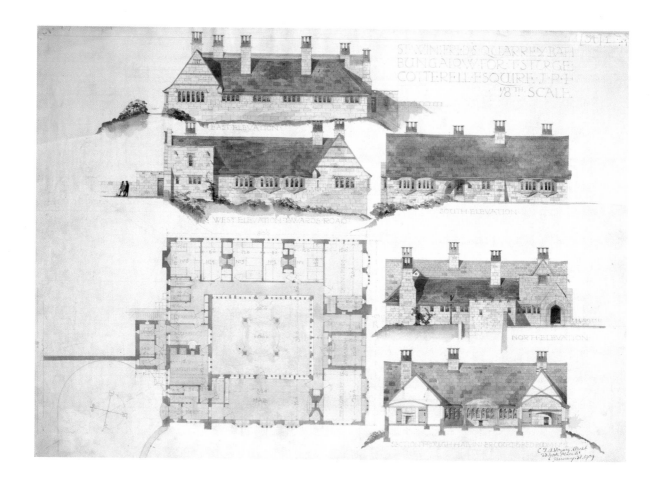

79. Design for Lodge Style, St. Winifred's Quarry, Combe Down, near Bath, 1909
553 x 770 mm

As the Georgian revival gained strength early in the twentieth century, Voysey's architecture became more overtly Gothic. He must have relished building Lodge Style (1909), near Bath, shown here in preliminary sketches; the client, a quarry owner, asked for a stone house reminiscent of the thirteenth-century Merton College, Oxford.

80. **Unexecuted design for tower blocks on the site of Devonshire House, London, 1923**
Pencil and watercolor on card, 265 x 365 mm

In 1923, for a site in Piccadilly, Voysey suggested a park surrounding three thirty-story apartment buildings. This sketch captures his vision of glass skyscrapers with Gothic towers at the corners.

in 1911—three full decades before his death. The Voysey house had become out-moded in England just a few years into the new century, as the fashion started to swing toward Georgian revival—exactly the kind of symmetrical neoclassical ar-chitecture Voysey deplored; in protest, his designs took on more overtly Gothic detailing (figs. 78-80). The outbreak of World War I meant that three house proj-ects he did have in hand were permanently shelved. His practice never revived.

The war years were unkind in other ways. His father, always his close companion, had died in 1912, and Mary Maria and Voysey lived apart after 1917. In his late fifties, he was of course too old to fight; he supported the cause by designing a "soldiers & sailors map of London . . . for the City of London National Guard," an advertisement for the Nation's Fund for Nurses, and pub posters in praise of home and family for the Central Liquor Control Board (fig. 81).[95] By April 1918, he was writing to Alexander Morton of the Morton Sundour textile manufacturing firm: "Again I am out of work and now in a very terrible plight. Within measurable distance of the workhouse. It is hard at 61 to get any kind of post. Can you help me by giving me anything to do?"[96]

Thanks to Morton and others, pattern design again became Voysey's mainstay, providing a more than adequate living in some years.[97] In the 1920s, Essex & Co. were still advertising "many papers by C. F. A. Voysey, the Genius of Pattern. These supply the Something Distinctive for which you are looking."[98] But in April 1929, Voysey told Morton, "I am in terribly low water and distracted by financial worry—I have no more than sixty pounds left. No one will commission an architect of seventy-two."[99] In June he reported that his £200 annual retaining fee from the Wallpaper Manufacturers Ltd. would be stopped unless he could also "induce the Weavers and Cotton Printers to contribute . . . It is very painful to me to go begging on my own behalf . . . Without that £200 I should have to leave my flat, sell all my furniture and bury myself in a slum."[100]

The next year, 1930, Voysey devised a nursery chintz depicting illustrator John Tenniel's famed *Alice in Wonderland* characters wandering in a Voysey landscape—a design that sold well for Morton for a number of years, but which must have given Voysey a pang, for he had always condemned the "ape-like" practice of copying.[101] Then, too, Wonderland had suddenly become headline news in 1929, when "the real Alice," Mrs. Alice Pleasance Liddell Hargreaves, emerged from obscurity to put the manuscript given to her by author Lewis Carroll (Charles Lutwidge Dodgson) up for auction, touching off an international

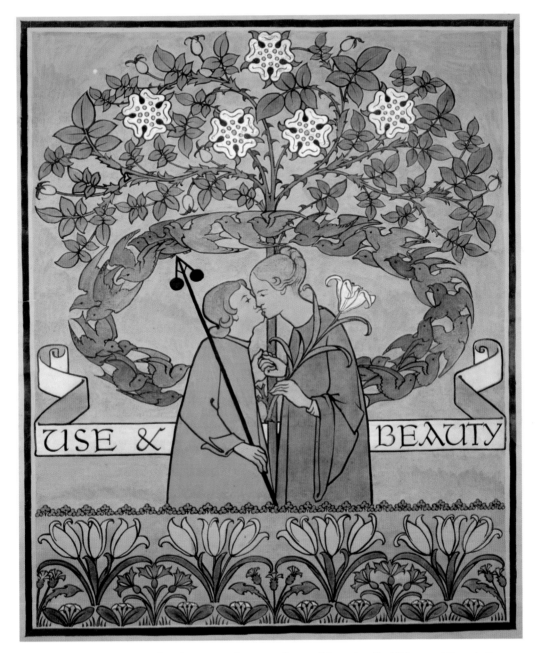

81. **Design for a poster for the Central Liquor Control Board called "Use and Beauty,"**
c. 1915–1918
 Colored washes and black outline on buff detail paper, 755 x 630 mm

In 1893 Voysey created a line drawing for the cover of the first volume of *The Studio* magazine, showing an allegorical figure of "Use" (holding a steam engine speed governor) embracing "Beauty" (holding a lily, symbol of purity). During World War I, he removed the magazine's title and turned the image into a poster for the Central Liquor Control Board. Hung in pubs, these posters extolled healthy values.

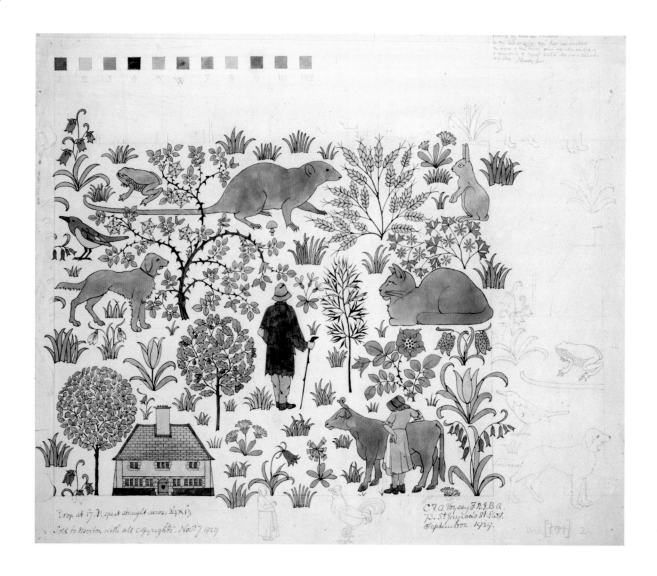

82. Design for a nursery chintz called "The House that Jack Built," 1929
Pen, pencil, and colored washes, 490 x 590 mm

Voysey's 1929 design for "The House that Jack Built" features a Voysey-type house, complete with a heart on the door. The rat and the priest (sketched in pencil at bottom) were removed from the final version, which was produced as a printed cotton by Morton Sundour.

wave of Alicemania that culminated in Hollywood's first Wonderland movie, a celebrity tour of America for the elderly Mrs. Hargreaves, and a flood of Alice products "from cigarettes to laxatives."[102] With the Wonderland chintz, which was followed by designs for Minton tiles also featuring Tenniel's characters, Voysey must have felt he was scrambling to capitalize on the latest craze, the sort of thing he had always scorned. In 1931 he wrote querulously to Morton: "At your last visit you had not a word of praise for my work and after I had shown you between 40 and 50 [designs] you asked if I could not show you something *fresh!*"[103]

AMID HIS TROUBLES, in September of 1929 Voysey drew and watercolored a children's pattern based on "The House that Jack Built" (fig. 82):

> This is the priest all shaven and shorn
> That married the man all tattered and torn
> That kissed the maiden all forlorn
> That milked the cow with the crumpled horn
> That tossed the dog that worried the cat
> That killed the rat that ate the malt
> That lay in the house that Jack built.

Taken at face value, the design is Voysey at his most engaging, evoking in simple lines and cheerful colors the plants and animals of the rural England that he loved. The composition is less random than it may seem at first glance: each animal focuses intently on the object of its action in the poem—the rat on the grain, the cat on the rat, and so on. The maiden keeps her gaze firmly on the cow. This progression breaks down with "the man all tattered and torn," who should have his eye on the maiden. Instead he has turned his back on her and on "the house that Jack built" (the very essence of a Voysey house, sheltered by an apple tree, its red door centered by a heart). The man holds a walking stick; is he starting a journey? Perhaps he is a tramp, not part of the scene, just passing through. He is placed at the very middle of the design; the action circles around him, and yet he seems curiously uninvolved.

Voysey apparently left no comment on the tattered man's identity, but John Brandon-Jones, a family friend, noted on the sketch that the priest penciled in

at the bottom margin was "a caricature of Voysey's brother who was a Unitarian minister." In 1900, Voysey, at the height of his career, sculpted a self-portrait in the form of a cheeky devil poking his tongue out at the world. It is possible that the tattered man is another self-portrait: Voysey in old age, with his marriage and his architecture career behind him. Although his coat is ragged, the tattered man in uncuffed trousers stands relaxed, grasping his staff but not leaning on it; his back is unbowed and his head is raised alertly. His attitude embodies a description of Voysey recorded by his nephew shortly after the architect's death:

> There was nothing forbidding about him and yet there was aloofness and distinction in abundance . . . Neglected he was, to a certain extent, but neglected by his own choice. He drew apart from the world, like many a great artist before him, simply because he couldn't altogether cope with his work and with the world at the same time.[104]

While the figure in the design can be seen as one who has turned *away*—from home, career, and romantic love, and even from his fellow man (the viewer)—he has also turned *toward* something: the wide and wild natural world. In *Individuality*, Voysey advised communion with nature, which he called "the fountainhead," to heal the spirit and refresh creativity by contemplating the individuality of animals and plants.

> It is no great step for the imagination to take, to read in animals and flowers the good sentiments we find in man. To do so certainly increases our interest in and sympathy with animals and plants; and if our interest is thereby increased, there is every chance that the work done in this state of mind will suggest to others very similar thoughts and feelings, and will keep our work fresh in the hearts of men for generations to come, when our names may be forgotten. Like our Cathedrals, which still warm and inspire us though we know not who built them. Sincere thought and feeling is transmittable through things material, soul responds to soul.[105]

As Hitchmough points out, it would be a mistake to see Voysey's last years as unremittingly bleak. He was elected head of the Art Workers Guild in 1924; his grandchildren were born in 1927 and 1929;[106] and in 1927 a five-part series

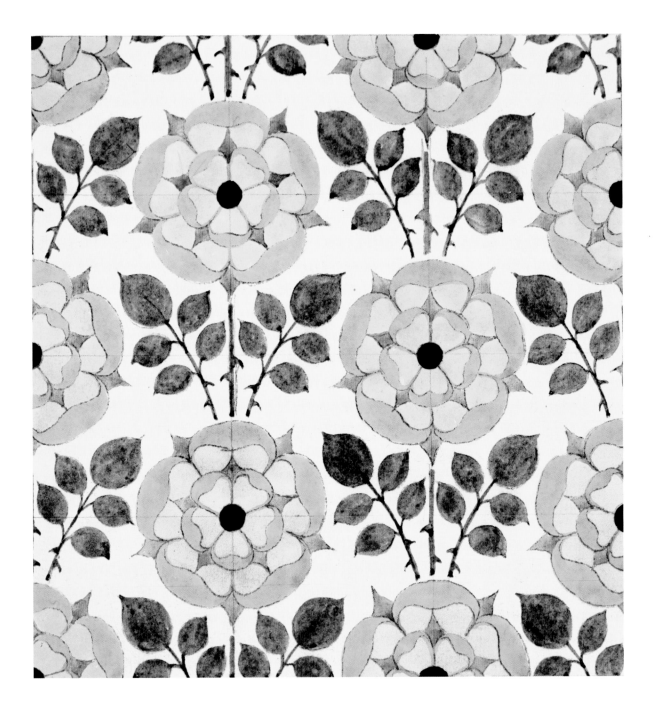

83. Design for textile, 1929
Pencil and yellow and green washes, 280 x 235 mm

in *The Architect & Building News* extolled his lifetime of accomplishment. The *Architectural Review* sponsored an exhibition of his work in 1931 (fig. 84), publishing appreciations by John Betjeman and Sir Edwin Lutyens in its October issue. In 1940, the Royal Institute of British Architects awarded him its highest honor, the Royal Gold Medal.

The years brought backhanded compliments as well. The inexpensive charms of his roughcast cottages were rediscovered in the twenties and thirties by suburban builders, and small unimaginative versions of these houses sprang up by the thousand in developments all over England. (Nikolaus Pevsner later observed wryly that "from the historian's point of view it remains no small feat to have created the pattern for the vast majority of buildings carried out over a period of thirty years or more."[107]) In his influential 1936 book, *Pioneers of the Modern Movement*, Pevsner placed Voysey high on the pioneers list—a distinction Voysey vehemently resisted: "This new style cannot last," he told Pevsner. "Our young architects have no religion. They have nothing to aspire to. They are like designers who draw flowers and trees without thinking with reverence of Him who created them."[108] The condemnation is an interesting echo of his rejection of Art Nouveau some forty years before: "The Art of to-day . . . shows no sign of reverence. Atheism, conceit, and apish imitation seem to be the chief features."[109]

When Voysey died in 1941, Pevsner wrote the *Architectural Review*'s memorial to "the dear old gentleman with the shrewd and kindly face."[110] In a radio tribute, his nephew-in-law, Robert Donat, noted that his Uncle Charles "chose his loneliness but he didn't particularly like it"; nevertheless, "he had all he needed and more, and his rooms in St James's Street, though simple, were extremely comfortable and were filled with beautiful things of his own designing."[111]

Voysey opened *Individuality* with the assertion that "there is a beneficent and omnipotent controlling power that is perfectly good and perfectly loving, [and] our existence here, is for the purpose of growing individual characters." Whether or not that is so, the conviction powered Voysey's life and work. His reverence, inventiveness, affection, and humor shine in his architecture and furniture, and especially in the best of his pattern designs. "Like our Cathedrals," they do "still warm and inspire us." Thought and feeling—call it spirit—*can* be conveyed through "things material," and "soul responds to soul."

84. Seventy-four years old in 1931, Voysey wore his customary lapel-less jacket to an exhibition of his work hosted by the *Architectural Review*.

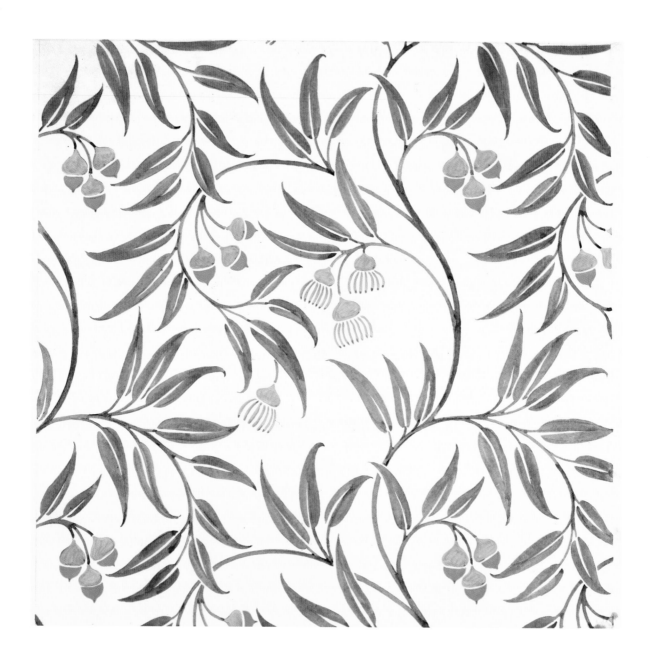

85. Design for a wallpaper showing eucalyptus leaves and flowers, 1928
Pencil and green, yellow, and red washes on tracing paper, 455 x 450 mm

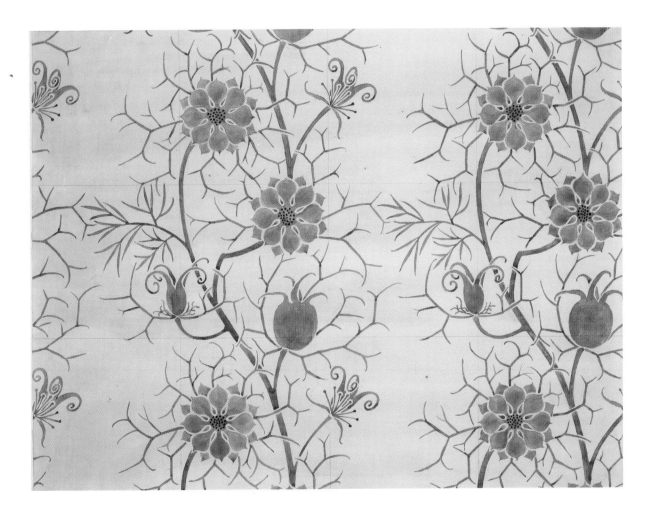

86. **Design for a textile or wallpaper called "Love-in-a-mist," 1928**
Pencil and blue and green washes, 470 x 580 mm

87. Design for a fabric, c. 1929
Pencil and colored washes on tracing paper, 460 x 300 mm

for Ceath only 49 x 16

For sale

Australian Finch.
nº 106.

C. F. A. Voysey Arch.t
B. S.t James's Street
S. W. 1. June 1925.

SB 48/Vor [758] 1

88. **Design for a textile called "Australian Finch," 1925**
Pencil, pen, and colored washes, 560 x 465 mm

89. Design, probably intended for a nursery wallpaper frieze, 1930
Print with colored washes, 320 x 715 mm

ENDNOTES

See the bibliography for full citations.

Chapter 1: Introduction

1. The quotations are from (1) "An Interview with Mr. Charles F. Annesley Voysey," 236; (2) Lutyens, "Foreword," 91; (3 and 4) Pevsner, "Charles F. Annesley Voysey," 113.
2. Lutyens, "Foreword," 91.
3. "C. F. Annesley Voysey: The Man and His Work," Pt. IV, 316.
4. Voysey, "Ideas in Things," 118.
5. Robert Donat, "Uncle Charles . . . ," *The Architect's Journal* XCIII (1941): 193–194, quoted in Brandon-Jones, "Introduction," 20–21.
6. Ibid.

Chapter 2: Becoming an Architect

7. E.B.S., "Some Recent Designs," 209.
8. Hitchmough, *CFA Voysey*, 13. Charles Voysey published *Theism, or the Religion of Common Sense* in 1894.
9. "C. F. Annesley Voysey: The Man and His Work," Pt. I, 133–134.
10. Betjeman, "Charles Frances Annesley Voysey, the Architect of Individualism," 93.
11. Brandon-Jones, "C.F.A. Voysey," 270.
12. Ibid.
13. "Autobiographical notes by C.F.A. Voysey," now in a private collection, or from an interview with Voysey in *The Leeds Mercury* (10 April 1936). Quoted in Hitchmough, *CFA Voysey*, 15.
14. Hitchmough, *CFA Voysey*, 16.
15. C.F.A. Voysey, Letter of 8 November 1910 to the *Evening Standard*, quoted in Hitchmough, *CFA Voysey*, 16.
16. Hitchmough, *CFA Voysey*, 16.
17. Voysey, *Individuality*, 89.
18. A.W.N. Pugin, "The True Principles of Pointed or Christian Architecture," reprint edition (London: Academy Editions, 1973), 47, quoted in Hitchmough, *CFA Voysey*, 39.
19. Hitchmough, *CFA Voysey*, 16–18.
20. Ibid., 18.
21. The facts in the remainder of this paragraph are taken from Hitchmough, *CFA Voysey*, 21–25.
22. Voysey, "1874 & After," 91.
23. Hitchmough, *CFA Voysey*, 34–35.
24. Durant, *C.F.A. Voysey*, 25.
25. G., "English Domestic Architecture," 25.
26. Ibid.

Chapter 3: Pattern Design

27. Voysey, "1874 & After," 91.
28. Ibid.
29. A. H. Mackmurdo, "Prospectus," K339, William Morris Gallery, Walthamstow, London, UK, quoted in Stansky, *Redesigning the World*, 99.
30. Hitchmough, *CFA Voysey*, 30.
31. Haslam, "Carpet Designs," 404.
32. E.B.S., "Some Recent Designs," 209.
33. "An Interview with Mr. Charles F. Annesley Voysey," 232–233.
34. Floud, "Wallpaper Designs," 12.
35. Ibid.
36. E.B.S., "Some Recent Designs," 210. The reviewer was referring to mushrooms in the "Fairyland" wallpaper design pictured in the article.
37. Floud, "Wallpaper Designs," 11.
38. Voysey, "Aims and Conditions," 46.
39. "An Interview with Mr. Charles F. Annesley Voysey," 233.
40. "Dinner to C. F. Annesley Voysey," *Journal of the Royal Institute of British Architects* XXXV (26 November 1928): 53, quoted in Hitchmough, *CFA Voysey*, 55.
41. Stansky, *Redesigning the World*, 70; Voysey, "1874 & After," 92. *Redesigning the World* provides a detailed discussion of Mackmurdo, the Century Guild, the Art Workers Guild, and the Arts and Crafts Exhibition Society.
42. Pevsner, "Charles F. Annesley Voysey," 112.
43. *The Builder's Journal & Architectural Record*, September 1896; quoted in Hitchmough, *CFA Voysey*, 18.
44. Brandon-Jones, "C.F.A. Voysey," 271–272.
45. "The Man and His Work," Pt. V, 405–406.
46. Aslin, "Pattern Design," 99.
47. E.B.S., "Some Recent Designs," 211–214.
48. Ibid.
49. "An Interview with Mr. Charles F. Annesley Voysey," 234.
50. Parry, *Textiles*, 97–99.
51. Greenhalgh, "The Cult of Nature," 59.
52. Aslin, "Pattern Design," 100.
53. Greenhalgh, "Le Style Anglais," 145.
54. Voysey, "L'Art Nouveau," 56.
55. Floud, "Wallpaper Designs," 14.
56. "An Interview with Mr. Charles F. Annesley Voysey," 233.
57. G., "English Domestic Architecture," 22.
58. Voysey, "Aims and Conditions," 46.

Chapter 4: The Heart of the Matter

59. "The Man and His Work," Pt. I, 134; Brandon-Jones and others, *C.F.A. Voysey*, 37–38.
60. "The Man and His Work," Pt. I, 134.
61. Unless separately footnoted, all quotations in this section are from Voysey, *Individuality*.
62. Voysey, "Ideas in Things," 113–114.
63. Voysey, "The English Home," 68.
64. Ibid.
65. Ibid.
66. Voysey, "Ideas in Things," 117.
67. Ibid., 115.
68. Ibid., 119.
69. Ibid., 118.
70. Ibid.

Chapter 5: At Home with Mr. Voysey

71. William Plomer, *Double Lives* (London: Jonathan Cape, 1950), 99–100, quoted in Simpson, *CFA Voysey*, 42.
72. Voysey, "'The Orchard,'" 35.
73. Ibid.
74. Voysey, "The English Home," 70.
75. Voysey, "'The Orchard,'" 35.
76. Voysey, "Ideas in Things," 119–120.
77. Voysey, "Symbolism in Design," unpublished typescript in the RIBA collection, quoted in Hitchmough, *CFA Voysey*, 142; Symonds, *C.F.A. Voysey*, 81.
78. Voysey, "Symbolism in Design," quoted in Hitchmough, *CFA Voysey*, 142; Voysey, "Ideas in Things," 123.
79. H. G. Wells, *Experiment in Autobiography*, Vol. 2, (London: Victor Gollancz Ltd. and The Cresset Press Ltd., 1934), 639, quoted in Hitchmough, *CFA Voysey*, 174.
80. Voysey, "Symbolism in Design," quoted in Hitchmough, *CFA Voysey*, 142.

Chapter 6: Humor and Grotesques

81. *The British Architect* LXXIII (4 March 1910): 160; quoted in Simpson, *C.F.A. Voysey*, 17.
82. Symonds, *C.F.A. Voysey*, 34, entry number 81.4; 70, entry number 514; figure 100.
83. Voysey, "Ideas in Things," 119.
84. Hitchmough, *CFA Voysey*, 35.
85. The corbel design, elevations, and perspective sketch appear in *The British Architect* XXXVI (1891): 210ff.
86. Hitchmough, *CFA Voysey*, 42.
87. Ibid., 79, 107, 102. Britten sundial: Davison, "Sundials," 146.
88. Symonds, *C.F.A. Voysey*, 45, entry number 138.5.
89. Durant, *Decorative Designs*, 6–7.
90. Hitchmough, *CFA Voysey*, 141, Fig. 2.
91. A stone version of the figure was installed as a garden ornament at Littleholme in Surrey. Brandon-Jones and others, *CFA Voysey*, 6, 29.

Chapter 7: Rise and Fall

92. This paragraph is based on the excellent discussions in Hitchmough, "Good Publicity," 54–61, and Hitchmough, *CFA Voysey*, 51–52.
93. Pevsner, "Charles F. Annesley Voysey," 113.
94. Brandon-Jones, "Introduction," 11.
95. Symonds, *C.F.A. Voysey*, 73, entry numbers 605 and 615.
96. Correspondence at the Victoria and Albert Museum; quoted in Hitchmough, *CFA Voysey*, 209.
97. Hitchmough, *CFA Voysey*, 209
98. Aslin, "Pattern Design," 96.
99. Durant, *C.F.A. Voysey*, 20.
100. Ibid.
101. Parry and Richardson, "Alice in Wonderland Furnishing Fabric."
102. Gordon, *Looking Glass*, 244.
103. Correspondence, 10 April 1931, at the Victoria and Albert Museum; quoted in Hitchmough, *CFA Voysey*, 210.
104. Donat, "Uncle Charles . . . ," 20–21.
105. Voysey, *Individuality*, 16–17.
106. Hitchmough, *CFA Voysey*, 210.
107. Pevsner, *Pioneers*, 131.
108. Pevsner, "Charles F. Annesley Voysey," 113.
109. Voysey, "L'Art Nouveau," 56.
110. Pevsner, "Charles F. Annesley Voysey," 112.
111. Donat, "Uncle Charles . . . ," 20–21.

NOTE: The Royal Institute of British Architects (RIBA) and the Victoria and Albert Museum have the largest public collections of Voysey designs and artifacts. To view hundreds of entries online, go to **www.ribapix.com** or **images.vam.ac.uk** and search on "Voysey."

"An Artistic Use of White Holly." *The Craftsman* (August 1903): 369-370.

"An Artist's House." *The British Architect* XXXVI (1891): 209-211.

"The Arts and Crafts Exhibition, 1896. (Third Notice)." *The Studio* IX, no. 45 (December 1896): 189-204.

Aslin, Elizabeth. "Pattern Design." In Brandon-Jones and others, *C.F.A. Voysey: Architect and Designer 1857-1941*, 96-100.

Betjeman, John. "Charles Frances Annesley Voysey, the Architect of Individualism." *Architectural Review* LXX (1931): 93-96.

Brandon-Jones, John. "C.F.A. Voysey." In Peter Farriday, ed. *Victorian Architecture*, 269-287. London: Jonathan Cape, 1963.

——. "C.F.A. Voysey: Introduction." In Brandon-Jones and others, *C.F.A. Voysey: Architect and Designer 1857-1941*, 9-24.

Brandon-Jones, John, and others. *C.F.A. Voysey: Architect and Designer 1857-1941*. London: Lund Humphries Publishers Ltd., 1978.

"C. F. Annesley Voysey: The Man and His Work." Pts. I-V. *The Architect & Building News* CXVII (1927): 133-134, 219-221, 273-275, 314-316, 404-406.

Davison, T. Raffles. "Some Modern Sundials." *British Architect* LIII (1895): 146.

Durant, Stuart. *C.F.A. Voysey*. London: Academy Editions, 1991.

——. *The Decorative Designs of C.F.A. Voysey*. Cambridge, UK: The Lutterworth Press, 1990.

E.B.S. "Some Recent Designs by Mr. C.F.A. Voysey." *The Studio* XII (May 1896): 208-219.

Floud, Peter. "The Wallpaper Designs of C.F.A. Voysey." *Penrose Annual* LII (1958): 10-14.

G. "The Revival of English Domestic Architecture, VI, the Work of Mr. C.F.A. Voysey." *The Studio* XI (1897): 17-25.

Gebhard, David. *Charles F. A. Voysey, Architect*. Los Angeles: Hennessey & Ingalls, Inc., 1975.

Gibson, J. S. "Artistic Houses." *The Studio* I, no. 6 (September 1893): 214-227.

Gordon, Colin. *Beyond the Looking Glass*. San Diego: Harcourt Brace Jovanovich, 1982.

Greenhalgh, Paul, ed. *Art Nouveau 1890-1910*. New York: Harry N. Abrams, 2000.

——. "The Cult of Nature." In Greenhalgh, *Art Nouveau 1890-1910*, 54-71.

——. "Le Style Anglais: English Roots of the New Art." In Greenhalgh, *Art Nouveau 1890-1910*, 126-145.

Haslam, Malcolm. "The Carpet Designs of C.F.A. Voysey." *The Magazine Antiques* (September 1991): 402-411.

Hitchmough, Wendy. *CFA Voysey*. London: Phaidon Press, Ltd., 1997.

——. "C.F.A. Voysey and the Art of Good Publicity." *Style 1900* 13, no. 2 (May 2000): 54-61.

Holme, Charles, ed. *Modern British Domestic Architecture and Decoration*. London: Offices of The Studio, 1901.

"An Interview with Mr. Charles F. Annesley Voysey, Architect and Designer." *The Studio* I, no. 6 (September 1893): 231-237.

Lutyens, Sir Edwin. "Foreword." *Architectural Review* LXX (October 1931): 91.

Muthesius, Hermann. *Das Englische Haus*. Vol. 2, *Anlage und Aufbau*. Berlin: Ernst Wasmuth, A. G., 1910.

——. *Das Englische Haus*. Vol. 3, *Der Innenraum*. Berlin: Ernst Wasmuth, A. G., 1911.

——. *Das Moderne Landhaus und Seine Innere Ausstattung*. Munich: Verlagsanstalt F. Bruckmann, A. G., 1905.

Parry, Linda. *Textiles of the Arts and Crafts Movement*. New York: Thames and Hudson Inc., 1988.

Parry, Linda, and Brenda Richardson. "More Information, Alice in Wonderland Furnishing Fabric." Victoria and Albert Museum collections online. http://collections.vam.ac.uk/item/O69054/furnishing-fabric-alice-in-wonderland, "More information" tab.

Pevsner, Nikolaus. "Charles F. Annesley Voysey, 1858-1941: A Tribute by Nikolaus Pevsner." *Architectural Review* LXXXIX (1941): 112-113.

——. *Pioneers of Modern Design, from William Morris to Walter Gropius*, 4th ed. New Haven and London: Yale University Press, 2005.

Simpson, Duncan. *C.F.A. Voysey: An Architect of Individuality*. London: Lund Humphries Publishers, Ltd., 1979.

Stansky, Peter. *Redesigning the World: William Morris, the 1880s, and the Arts and Crafts*. Princeton, NJ: Princeton University Press, 1985.

Symonds, Joanna. *C.F.A. Voysey: Catalogue of the Drawings Collection of the Royal Institute of British Architects*. Farnborough, Hampshire, UK: Gregg International, 1975.

Valance, Aymer. "British Decorative Art in 1899 and the Arts and Crafts Exhibition." Pt. 1. *The Studio* XVIII, no. 79 (October 1899): 37-50.

Voysey, C.F.A. "1874 & After." *Architectural Review* LXX (October 1931): 91-92.

——. "The Aesthetic Aspects of Concrete Construction." *The Architect and Engineer* 57 (May 1919): 80-82. Reprinted in David Gebhard, *Charles F. A. Voysey, Architect*, 72-76. Los Angeles: Hennessey & Ingalls, Inc., 1975.

——. "The Aims and Conditions of the Modern Decorator." *Journal of Decorative Art* XV (April 1895): 82-90. Reprinted in David Gebhard, *Charles F. A. Voysey, Architect*, 43-53. Los Angeles: Hennessey & Ingalls, Inc., 1975. Page references are to the reprint.

——. "Domestic Furniture." *Journal, Royal Institute of British Architects* 1: 415-418. Reprinted in David Gebhard, *Charles F. A. Voysey, Architect*, 39-42. Los Angeles: Hennessey & Ingalls, Inc., 1975.

——. "The English Home." *British Architect* LXXXV (January 27, 1911): 68-70.

——. "Ideas in Things." In T. Raffles Davison, ed. *The Arts Connected with Building*, 101-137. London: Batsford, 1909. Reprinted in Stuart Durant, *C.F.A. Voysey*, 113-125. London: Academy Editions, 1991. Page references are to the reprint.

——. *Individuality*. London: Chapman & Hall, 1915. Reprint edition Longmead, Shaftesbury, Dorset: Element Books, 1986. Page references are to the reprint edition.

——. "On Town Planning." *Architectural Review* 46 (July 1919): 25-26. Reprinted in David Gebhard, *Charles F. A. Voysey, Architect*, 77-81. Los Angeles: Hennessey & Ingalls, Inc., 1975.

——. "'The Orchard,' Chorley Wood, Herts." *Architectural Review* X: 32-38.

——. "The Quality of Fitness in Architecture." *The Craftsman* 23 (November 1912): 174-182.

——. Remarks by Voysey excerpted from "L'Art Nouveau: What It Is and What Is Thought of It: A Symposium." *The Magazine of Art* 2:211-212. Reprinted in David Gebhard, *Charles F. A. Voysey, Architect*, 56. Los Angeles: Hennessey & Ingalls, Inc., 1975. Page reference is to the reprint.

——. "Remarks on Domestic Entrance Halls." *International Studio* 21 (1901), 242-246. Reprinted in David Gebhard, *Charles F. A. Voysey, Architect*, 54-55. Los Angeles: Hennessey & Ingalls, Inc., 1975.